Pricing *Your* Portraits

High-Profit Strategies for Photographers

Jeff Smith

AMHERST MEDIA, INC. BUFFALO, NY

Jeff Smith is a professional photographer and the owner of two very successful studios in central California. His numerous articles have appeared in *Rangefinder, Professional Photographer,* and *Studio Photography and Design* magazines. Jeff has been a featured speaker at the Senior Photographers International Convention, as well as at numerous seminars for professional photographers. He has written seven books, including *Outdoor and Location Portrait Photography; Corrective Lighting, Posing, and Retouching Techniques for Portrait Photographers; Professional Digital Portrait Photography; Success in Portrait Photography;* and *Portrait Pro: What You Must Know to Make Photography Your Career* (all from Amherst Media®). His common-sense approach to photography and business makes the information he presents both practical and very easy to understand.

Copyright © 2015 by Jeff Smith.
All rights reserved.
All photographs by the author unless otherwise noted.

Published by:
Amherst Media, Inc.
P.O. Box 586
Buffalo, N.Y. 14226
Fax: 716-874-4508
www.AmherstMedia.com

Publisher: Craig Alesse
Senior Editor/Production Manager: Michelle Perkins
Editors: Barbara A. Lynch-Johnt, Harvey Goldstein, Beth Alesse
Associate Publisher: Kate Neaverth
Editorial Assistance from: Carey A. Miller, Sally Jarzab, John S. Loder
Business Manager: Adam Richards
Warehouse and Fulfillment Manager: Roger Singo

ISBN-13: 978-1-60895-871-9
Library of Congress Control Number: 2014955655
Printed in the United States of America.
10 9 8 7 6 5 4 3 2 1

Check out Amherst Media's blogs at: http://portrait-photographer.blogspot.com/
http://weddingphotographer-amherstmedia.blogspot.com/

Contents

5. No Simple Solutions . 76

6. Sales Models and Pricing 85

How *Not* to Price Your Portrait Photography

There is a long-running joke about the typical photographer's business skills. Back when I started in photography, I was told, "Look at what all the other photographers are doing—and then *do something else!*" That is advice that, sadly, has served me we well.

Don't Follow the Leader

Photographers have always played a sort of "follow the leader" strategy of business, looking at other photographers and studios as a model for everything from how they price their work to how to market their work to attract clients. The resulting problem is this: when you follow another photographer, in most cases you are following someone who is following someone else—with no idea of exactly *why* they price their work or market their business the way they do. Blindly following other photographers usually ends up in disaster.

You Might Not Be Following Success

In our area, many photographers have looked at what I was doing as a lead to follow for their own success, since most of them have read my books. I recently had a paid display at the most popular movie theater in our area. It was attached to the largest/nicest outdoor shopping area in our city, so this is where all the high school students we want to attract went to the movies. We spent $400 a month for a 3x5-foot, two-sided "standee"—a free-standing A-frame display consisting of two black frames with hinges at the top and long tray screwed into the side to stabilize

> Blindly following other photographers usually ends up in disaster.

the unit and hold advertising materials. To draw the attention of each person leaving the cinema, we used many large photos of local seniors on each side of the display and posted our studio's name prominently.

We did this for two years and tracked our senior bookings to determine how many of them came to us because they saw the display. We also tested the name recognition from the cinema patrons. After all that, one thing became clear: our $4800 a year could be better spent marketing in other ways.

Realizing the follow-the-leader mentality that most photographers have, guess what happened the minute our contract ended and the display came down? Another larger studio in our area signed a contract to take our place to advertise to the seniors.

Guess what happened the minute our contract ended and the display came down?

> This photographer was successful enough to know better than to follow the leader.

This photographer was successful enough to know better than to follow the leader. If it worked, I never would have left. So what he thought was a ticket to high-school senior portrait success was a $400-dollar-a-month payment with little or no additional business.

You Might Not Have All the Information

Another obvious blunder of the follow-the-leader mentality is exemplified by the yearbook ads that we had to purchase under our school contract. There is no worse advertising dollar spent than one that is spent on a yearbook ad—an ad that comes out once a year and isn't the section of the book that people look at. Every year, though, new photographers saw I advertised in the yearbook and bought an large ad, figuring I knew what I was doing. They were right; I *did* know what I was doing—but, in this case, my intention was *not* to buy quality advertising for my business. Taking the ad didn't promote my studio at all. Instead, it helped fund the yearbook and the senior portrait yearbook contract. Unless you have access to *all the information*, your business deci-

◄▼ *(facing page and below)* Taking a blind follow-the-leader approach can lead you far astray in your pricing, marketing, and shooting. In order to succeed, you have to understand *your* business and *your* clients.

sions might be better made by learning how to make your own decisions.

Pricing

Following the leader can cost you even more when you base your pricing on the prices that another photographer charges. In classes and via e-mail, I get so many questions on this exact subject: How much should I charge? I always ask each person what they are currently charging for their work and whether they sell portraits (prints), images provided on a DVD, or if they bill for their time. (Later in the book we will discuss all these types of delivery and how they impact the way you should set your prices.)

Young photographers seem to start off offering DVDs of all their images, but eventually they realize the difficulty in this delivery system and then start selling prints from the images they take. On the low end, I have been told by "working photographers with clients" that they double the price that Costco charges for their printing. At the high end, I know of some photographers charging $75 to $100 for an 8x10-inch print. In this economy, and in the current professional climate, there are not as many of those high-end photographers charging $100 for an 8x10 as there used to be—but there are some!

Practical Example

After I conducted one class, a young lady talked to me about her pricing. She was a photographer who printed her work out at Costco and then doubled or tripled the price that Costco charged for the printing of the portrait order. For some of you reading this book, this sounds

◂▸ (right and facing page) Print costs are only a small part of the investment you make in creating a professional-quality portrait.

You can't use print costs as the base from which to multiply.

absurd—for others, this sounds familiar. I am not telling this story to embarrass anyone, just to give some perspective on the differences in pricing and how far off some photographers are when they follow others as a guide on what to charge to ensure a sustainable profit.

At the end of a class, I normally answer a few questions and then I am on to the next thing I am doing. This young lady really needed some help, though, so I talked to her in a little bit more detail about what she was charging and how she should *not* be pricing her work.

When selling prints/photographs and trying to calculate a multiplication factor, you can't use print costs as the base from which to multiply. Print costs, especially at Costco, are the least expensive part of the photographic process. As I explained this to

the young lady, she looked very confused *because so many of her friends in photography used the same pricing system.*

I started by asking her what the cost of an 8x10-inch print was. She said a very low price, under $2. That was the printing cost. But what other costs go into you providing that 8x10 print to a client? She thought for a moment and said, "My gas to get to the location." With gas at $4 a gallon, if she drove more than 8 miles each direction (in the average car) she was losing money on any client that only ordered one 8x10 print! She then argued that most clients buy more than just one 8x10—and while this might be true, you can't base your pricing and the profit of your business on the best-case scenario. You must set your pricing based on the worst-case scenario and offer slight discounts on larger orders (notice I said *slight!*).

I then asked her what other costs there were in that one 8x10-inch image. She couldn't think of anything else. I asked her if she edited the image before printing. She said yes. I asked

▲ ▶ *(above and facing page)* Location sessions involve, at the very least, transportation costs that have to be figured into your pricing.

You can't base your pricing and the profit of your business on the best-case scenario.

What if you make a mistake and you need to have the photograph reprinted?

her if there was time involved photographing and if she charged a sitting fee to cover that expense. She did not! I asked her how long a session took; she said an hour. I asked her how long she took to edit an image. She said her "photographic style" required her to spend a lot of time in Photoshop, so about thirty minutes. So, that 8x10 takes an hour and a half to produce.

Let's say you value your time as much as a fast food employee at In-N-Out Burger—about $10 per hour. So that adds $15 to the cost of the 8x10-inch print. With just these factors, I explained to her, the *real* cost for an 8x10 is the $2 printing costs, the $4 for gas, and the $15 for her time. At this point, we're up to $21 in costs associated with producing that print—but that is not all! What if you make a mistake on the color correction or density and you need to have the photograph reprinted? That's another cost you have to plan for! What happens if your client writes you a bad check and your bank charges you a $30 fee because it caused an overdraft in your account?

While you can't factor in the full cost of every "holy crap!" moment, things like that can and will happen to you when

They don't realize how much of their time they are giving up for the pennies they make from their work.

dealing with the public. You have to calculate in enough profit that, no matter what, you will not *lose* money doing your work. At the prices she was charging, this young lady could have sat at home and watched television or played video games and *lost less money* than she was losing when photographing a client!

This is a reality in our profession today. Photographers are so excited about photography that they rush into working with clients, hoping to make a quick buck. Unfortunately, they don't realize how much of their time they are giving up for the pennies they make from their work. I have heard photographers talk about making $100 for doing a wedding that they were at for eight hours. That is $12.50 an hour. Some young photographers think, "Well, that is more than I make at my regular job!" But then you have to edit, save, and burn all those images—so, again, you are losing money to work in photography!

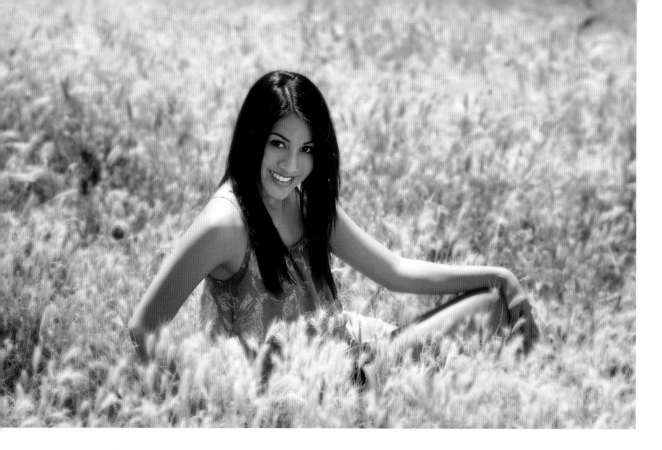

About This Book

In this book, I am not going to tell you what to charge. I am going to teach you how to calculate your prices to ensure a profit and to grow a business. When you sell a product, you are a *retail business*. The average retail business marks up its product from 4 to 7 times the entire cost of the product. If a dress costs the store $15 wholesale, they will price it from $60 to $105 for retail sale. This is called making a profit—because, in addition to the price paid for the dress itself, there are all kinds of costs associated with getting that dress from the shelf to the shopping bag. These are the same costs that a photographer incurs in the process of attracting a potential client all the way through to that client purchasing portraits from the business.

You run a photography business and that is all about *selling* photographs, not just creating them. That means that your business system, of which pricing is a fundamental part, has to be developed to an even higher degree than your photography skills.

When photographers argue this point, I use the obvious example. There are crappy photography companies and corporate studios that make a lot of money, and there are a lot of really good photographers who make little or nothing. Many of those *really good* photographers never even get to a point where they can support themselves in this industry. Doing that requires more that photographic skills; it requires developing a business system to sell your photography—one that gets prospective clients in the door and then sells them the photography you have created for a price that pays the bills and provides you a profit to live on. That is the first topic we will discuss.

1. Profit

Profit is the primary objective and function of any business—more than producing the product they sell, and more than determining the price they will sell it for. If your business doesn't create a profit, and if you as the business owner don't make profit your primary concern, then you don't have a business, you have an adult version of a lemonade stand. Your parents would spend $20 for lemons, sugar, ice, cups, and building/decorating your stand to give you the experience of making $6 on your own. Most photographers use the same strategy for their photography business. They use their wife's money, or the money that should be spent on their children, to fund their adult lemonade stand—their photography boondoggle. If you love photography and don't want to worry about profit, get yourself a job or career and make photography your hobby.

> If you don't want to worry about profit, make photography your hobby.

What Is Profit?

The most misunderstood aspect of running a photography business is profit. Profit is not the amount of money that you receive above and beyond the printing costs. Profit is the amount you have left over after you pay all the bills incurred in running your business. It is the small amount that is left over on your tax form after all the expenses and deductions have been taken out. As we have already discussed, there are many expenses involved with any portrait session or wedding booking. Even if you are willing to work for nothing and not be compensated for your time, the cost of each portrait you deliver is much higher than most photographers ever dreamed. So there we have it—the two main fac-

(facing page) In order to charge high enough prices to ensure a profit, you have to be confident in your skills and the images you create.

tors involved in turning a profit: pricing and costs. Once you've established a profitable approach, we'll also look at how adjusting the volume of your business can improve your profit structure. In this chapter we'll go over these concepts in broad strokes; we'll return to each of them in greater detail later in the book.

Pricing

Pricing is the first consideration of profit. Without the proper pricing of your work, profit will not be possible. Some photographers get really confused about this; I know I did. Years ago, when I did weddings, I would listen to everyone who told me I needed to increase my prices. Even though I was nervous about running all my business off with a 15 percent increase in my pricing, I would raise my prices. But then, because I was uncertain anyone would pay the new prices, I would redesign my packages to give away more products and services or I would reduce the price of additional portraits ordered from the same pose. As a result, I actually made *less* profit from my new price list with higher prices than I did with my older packages that had a lower price! I raised my prices to lower my profits.

Insecurity Leads to Underpricing

You have to set your prices high enough to turn a profit, even if the client only buys an 8x10- or 5x7-inch print. At the same time, you can't price your work higher than the market will bear—or higher than your skill level can support. That said, most photographers are so underpriced that charging more than the market will bear isn't even close to happening. Clients will spend *so much more* than the average photographer thinks they will on quality photography.

This is one of the problems with the way in which many people start into photography today. They have no training and few skills, which results in a lack of confidence in what they charge. It takes a confident professional to look a client in the eye and say, "This portrait is $1500. Wouldn't it look beautiful hanging over the sofa in your living room? How do you feel about this size?" I can say that with confidence because I just created a beautiful portrait of the most important people in that person's life. I even

Without the proper pricing of your work, profit will not be possible.

Money Buys Respect

We cherish the things in our life that are expensive; we do not value things that are really cheap. A few years ago, my family and I went to Thailand. We rode elephants, we took river tours, and we shopped like crazy. I love wearing suits—and there is no one who loves ties more than I do. When I shop in the United States, most of the ties I buy cost between $50 and $100. I treasure these ties because they are beautiful and expensive. While I was in Thailand, I found designer silk ties (or at least good knock-offs) that I could buy for $2 each. It was amazing—and I must have bought fifty of them! When I got home, I wore some of them and I gave many of them to my friends. But I noticed that when I ate or drank something, I would always get something on these ties. And rather than have them dry cleaned, I would just throw them away. I also noticed that when I wore one of my expensive ties, I made sure I didn't get a spot on it—even if I had to take it off or throw it over my shoulder. Many times in life, what you *pay* for something is an exact predictor of how much you will value it. You might create beautiful photography, but if you charge nothing for it, most people will not respect it or you!

show my clients unretouched, unedited images because I light, pose, and plan my photographs to make sure the originals out of the camera are 95 percent as good as the final images will be! I know that if my clients don't buy the portrait, or if they buy it too small, *they* will be the ones that lose out.

You can't charge a fair amount for your work if you doubt your abilities, the quality of work you create, and the value the client puts on the images you produce. If you doubt your abilities, you will always try to undercut the rest of the market in the hope that potential clients will accept a lesser quality to save money. If you are that person, you will never turn a true profit in this profession.

Your Skill Level

At the low end of pricing, you cannot consider your skill level or the quality of your work when setting the price that has to be charged for you to make a profit. (At the higher end of the pricing scale, skill *is* a factor; if you can produce images that no one else can, those unique skills will command premium pricing.) If you are just starting out, there is only so low you can set your pricing before you get to a point where it is costing you to work for someone—not to mention the fact that you are embarrassing yourself by charging less than what a session costs you. If your skills do not allow you to create the quality of work necessary to charge the amount needed to turn a profit, I suggest you raise the quality of your skills. Buy a book, go back to school, do whatever it takes. If you can't make a profit, you are not a professional photographer; you, my friend, have an expensive hobby.

▲ The cost of props and backdrops have to be figured out and averaged into the prices of your portraits.

Costs

Pricing, of course, affects the profit of your business, but so do costs and overhead. Even if you charge a really high-end price—say $100 for every 8x10-inch print you sell—and have a business system in place that creates a demand for large number of those prints, *your business can still lose money* if you don't control your costs and overhead.

A Repeatable Process

Costs are often a hard thing for a young businessperson to control. While prices are set and published, most photographers' business prac-

tices are not quite as set in stone, so their costs can vary widely. Most of the time, you can't go back to a client for more money because you spent too long taking the photographs or the album company no longer offers the cheaper wedding album you normally use and you had to buy the more expensive one. For pricing to be effective, you must develop a repeatable process—a normal and consistent way you use to create your work. Once you create this workflow, you never deviate from it unless the customer is paying for additional services.

Young photographers often make many bad decisions that raise the cost of any given portrait

session or wedding because they constantly change the business process that is put in to place to control costs. Let's consider an example. After reading my books, the photographer realizes that he has sloppy impulse control; he is overshooting and spending way too much time sorting and editing the resulting plethora of nearly identical images. Therefore, he develops a workflow that has him taking only five to seven shots of any pose—*maximum.* This reduces the cost of editing down more images than he needs. This idea sounds great and works well . . . right up until a bride or portrait session subject is very attractive. Then the photographer goes right back to overshooting, taking a ridiculous number of photos for every pose and scene, then editing down the overwhelming number of files that result from that approach. All these additional images, and the time to process them, must be accounted for in the cost of that session or wedding. Just like in the days of film, there are *true costs* involved every time you push the shutter release button. With the costs of film and processing, you would get a bill for those amounts—but the *time* costs are just as real, whether it is your personal time or that of your employees.

Fantasy or Nightmare?

During a class I conducted, we were talking about raising prices and charging more for our work. One guy jokingly said he would like to sell his portraits for $500,000 and have one client a year so he could plan the perfect portrait. While everyone fantasized about that scenario, I said, "But what if you had a slow year?"

Employee management is another common area where photographers have trouble following their normal and established workflow for a session or event. Too often, photographers fail to figure in the cost of an assistant to go with them to a portrait session or wedding. Then, at the last minute, they ask a friend or family member to help out (so they feel more comfortable) and decide to pay them $10 an hour that wasn't accounted for.

When you calculate your costs, you must establish a "standard"—a way you photograph *everything*. Otherwise you can't determine the total cost or set your pricing appropriately. Once that "standard" is set for your business, you also have to resist the temptation to deviate from it. If you base your pricing on taking no more than seventy shots at a portrait session, then you take seventy shots—no matter how beautiful the subject is. Impulse control is a problem for many photographers. More isn't better . . . as a matter of fact, it's *worse*. When you have too many choices, the client often gets frustrated and can't make up their minds. To them, selecting the best image from that vast sea of images seems like a difficult chore. And when people feel like something is going to be difficult, they put it off! This means you're going to wait weeks, months, or even years to get your money—all because you couldn't control your impulses.

You have to control every cost of your business or it will quickly eat up all of your profit. I know it isn't fun. I know you would prefer to

◀▶ *(facing page and right)* Part of controlling your costs is controlling how much you shoot. Careful lighting and posing will minimize the number of shots you need to sort through at the end of the session.

be a free-spirited artist and take thousands of images of a single beautiful person—images that, in a world that was right and just, people would just magically give you money for. But business is business, if you can't charge a fair price ("fair" as in "makes a profit") and control your costs, you simply won't be in business. So, really, what seems like a choice isn't a choice at all—if you want to remain a photographer!

Time Is Your Most Limited Resource

Time is more important to successful people than what they charge and the costs of their product. Every successful person gets to a point where they simply have no more time. Again and again, you will see me mention the time *vs.* money trade-off: in life, you can have time or you can have money. For photogra-

▲▶ (above and facing page) Even with a pretty subject, you have to exercise self-control and stop yourself from wasting time overshooting.

Unless you can clearly see the time-wasters in your life, you will never be as financially successful as you could be.

phers, staying busy—having to get to the next assignment/job—always helps keep them out of trouble "profit-wise." If you've scheduled your time, you can't overshoot, or sit around talking after the session, or wander off to the camera store to look at the newest model of camera or lighting.

This involves both time management and self management. You can plan every second of your day on a planner, but unless you can clearly see the time-wasters in your life you will never be as financially successful as you could be. Facebook, endless texting, Pinterest, on-line dating, sports leagues, sleeping excessively—all of these things take time out of your day and, in most cases, money out of your pocket. Even if these bad habits don't cut into your profits, they'll lead you to become the kind of person who is always complaining about "having no time" to get things done. In most cases, people don't lack time; they lack direction and self control.

Many photographers think that delegating to employees is the answer, since it can let the primary in the business focus on the most productive, money-making tasks. This is a good solution if you are legitimately running out of time. It makes no sense when you have little or no business; you can't justify hiring someone to edit your images down to a workable number while you sleep on your mom's sofa!

I photograph primarily high-school seniors, as most of you know. Each day the studio is open, I photograph a senior every 45 minutes—whether it is twelve seniors a day in the summer or five seniors a day in the winter months. One appointment is right after the other to maximize my time. Even during the buzz of holiday activities, when very few seniors want to be photographed, I still schedule my sessions back-to-back and 45 minutes apart. Once I am done with the day's sessions, I am free to work on everything else—like marketing, so I can fill the rest of my days with additional business.

We'll look at costs and overhead in greater detail in chapter 3.

> Each day the studio is open, I photograph a senior every 45 minutes . . .

Volume

Volume—the amount of business you do each week, each day, each hour—also determines your profit. Once you have set your prices to make a profit, controlled your costs to ensure you're keeping that profit, and learned to manage yourself and use your time effectively, then you need to accelerate your profits with your volume. The costs/overhead associated with running a business are a constant—the rent, electricity, water, insurance, etc. are predictable, everyday expenses. With those set costs in place, whether you photograph one person or ten will greatly change the profit structure for your business.

The "More" Syndrome

Volume is only a good thing *after* you have established a pricing structure to ensure a profit. Increasing the volume of your business before you establish profitable prices only increases the velocity at which you lose money. This used to be called the "more" syndrome by one business/photography speaker. Too often, young photographers think that the solution to every problem is to do *more!* One photographer who followed the suggestions I am giving you in this book to calculate his costs and profit told me he made an amazing discovery: for every wedding he shot at his existing prices, he was *losing* $100! When asked what he was going to do, he responded, "Isn't it obvious? I need to do more weddings!" While the humor of this is lost on some photographers (and, okay, I might have exaggerated a bit to make my point), lots of inexperienced photographers share this thinking that more business is the key to their success—and, in many, cases it isn't.

Adapting Is Critical

Survival in business is about adapting to changes. The senior portrait business has changed dramatically over the past few years. Just a few years ago, boutique studios would have seniors come in for a session that lasted hours, while serving champagne to the senior's mother and her friends. Since the economic downturn, many of those studios are no longer in business. They relied on a very low volume and a very high price to survive and couldn't increase the volume of their business while adjusting to the cutbacks that most clients were making. The studios that made it through were the ones that were able to add smaller packages and shorter session times and stay relevant in this market. Spending less time with each senior let them increase their volume while retaining an adequate profit margin.

Always increase your prices slowly to see how each increment affects your volume.

New Businesses: Marketing to Manage Volume

Many young photographers don't realize that, when you first start your business, volume is controlled by your *marketing*, not your *pricing*. It is through your marketing that you can reach lots of prospective clients and get the phone ringing. Unless new clients are contacting you, it doesn't matter how low (or high) your prices are. Dropping your prices won't increase your volume if your marketing program isn't already inspiring your target market to reach out and book a session.

Established Businesses: Pricing to Manage Volume

Once you have an established business, you can help control your volume by *raising* your pricing. You will find that most clients don't even notice a 20 percent increase in pricing—especially considering how cheaply the average photographer prices their work. Therefore, implementing several small price increases over the course of twelve to eighteen months is a good way to manage the number of clients you have. This is perfect if you are maxing out the number of appointments you can handle. Always increase your prices slowly to see how each increment affects your volume.

This is one reason underpricing is a huge problem. Here's the scenario. You start out charging $1.50 for an 8x10 print, double the price at Costco. Then, when you realize how much money you are losing, you suddenly try to bump that print price up to $20 (that's just used as an example—it might be much more!) to cover your costs and allow for some profit. What's going to happen to your volume? It's going to disappear. Your current customers, most likely folks just looking for a bargain, are not going to stick around for a 1300 percent price increase! You will lose most if not all of the people you work with. (Of course, I would say that is *good*—you don't need to photograph people to go into debt! You can just stay in bed and do that.)

2. Cash Flow

The term "cash flow" is pretty much self-explanatory: it's the movement of cash into your business. Believe it or not, it is your job as a business owner to ensure proper cash flow. By planning the pay cycles of your clients you can plan the cash flow of your business.

Planning Pay Cycles

When it comes to getting paid, what you *don't* want is one "lump sum" payment—unless that lump sum is paid *before* the services are delivered. If a bride meets you two years before her wedding and wants to pay for the package up front, *please take her money* and have her sign an agreement/contract that outlines everything! It would be nice if all brides were like that, but most brides will try to pay as little as possible to get you to reserve the date and then hope that someone in her life comes up with the money to pay you on the wedding day or after the wedding is over.

Contracts

This is why contracts are important—with all your clients. Let's continue thinking about a wedding client for the moment. (*Note:* I am not an attorney. We'll go through some concepts in this section, but the actual wording in your agreement should be approved by your lawyer.)

A wedding contract is an agreement between the photographer and the bride. It outlines what the bride is getting (prod-

Believe it or not, it is your job as a business owner to ensure proper cash flow.

▲ Having every client sign a contract before the session makes sure you're each on the same page prior to any pictures being created.

ucts, services, and maximum time), important times of the wedding day, an approximate date when the images will be delivered, and a statement that if you fail to provide the wedding images the extent of your liability is the refund of all deposits paid. Some photographers add a clause about "no showing" for a wedding, which covers you in the event that something out of your control (like a serious auto accident on the way to the wedding) prevents you from completing the job.

The contract must also clearly specify the payment schedule and the additional charges that will accrue if she wants you to stay longer than the time included in the package. When I shot weddings, I required a non-refundable deposit of half of the package price be paid on the day we signed the wedding contract. The second half was due sixty days before the wedding date.

Payment Schedules

Why sixty days? With weddings, the biggest financial pressures are put on a couple in the last thirty days before the wedding. That's when *everyone* wants to be paid. And, let's be honest, that pressure sometimes results in the wedding being called off. By requiring payment before this pressure point, I've ensured that I am paid

for that date—one I've usually been holding for them for a year. Whether someone reserves your time for a session or wedding, you cannot accept other work for the same time, so they have bought it. With sixty days notice, I might be able to book *something* else for that day, but it probably wouldn't be another large wedding. The fact that I've collected a non-refundable 50 percent deposit helps make up for that. I would feel bad if I kept 100 percent of the fee if they canceled a year before the wedding date—but if they cancel at the thirty day mark, there's a good chance that the day I'd set aside for them would be totally wasted.

Policies that are good for cash flow are good for business. If you start doing a lot of weddings, your bills get paid each month because you have the first 50 percent of the wedding package money coming in at your first meeting or the contract signing—and the second half will be coming in sixty days prior to the wedding. If you do ten weddings a year, you have just created twenty paydays for your studio—money that is coming in before the services are delivered. This is how a business creates cash flow and stays in business.

Some photographers even schedule their payments so they have deposits alternating between the first and the fifteenth of the month—to ensure there is money coming in at the beginning as well as the middle of the month. Personally, I am happy knowing the money is coming in on the first, when the majority of my bills are due. Some people will inevitably be late paying their deposit, so I never stress over my mid-month cash flow (more on late payments at the end of the chapter).

Sitting Fees

Good cash flow policies make it easier for the client to afford your services. Photographers often argue about the need for a sitting fee (sometimes called a "creation fee"). This is a separate fee that is charged to cover the costs of taking a client's photo.

The Problem with No Sitting Fee

Let's say you don't charge a sitting fee. You drive all the way to the country to photograph a family in their nice country home. When you get there, you notice that Mom, Dad, and one of the daughters are very, very heavy. You

▲▲ *(facing page and above)* Charging a sitting fee for the session covers the basic costs of creating the images, ensuring some income even if the client places only a small order.

work hard to hide their size—you have them wear black, you use elements of the scene and strategic positioning of the thinner children to hide the heavier relatives' body mass to make everyone look as good as possible. You work hard and, in the end, you are proud of how good these folks look in their photos.

After the session, you pull out your laptop to show the family their images on their 80-inch television. You understand, like I do, that the excitement for buying photographs is never higher than right after the session is over. You have also practiced your craft to ensure that, right out of the camera, the images are 95 percent as good as the final images.

So, the first image that comes up and the mother moans out in pain. She says, "Oh my god—I look fat!" Her large daughter yells out, "Ugh! I look like a pig—I don't really look like that!"

You try to reassure them about the way they look in the images, but they won't listen. They are convinced you used the "fat lens" and made them look this swollen. After yelling, crying, and a lot of drama, the family agrees that you clearly don't know what you are doing as a photographer.

Because you didn't charge a sitting fee, the family *has not spent a dime* at this point. You, on the other hand, have invested not only your time but the hard costs of travel, an assistant, etc. You try to get this family to take another session in hopes you

When someone reserves your time, they have to pay – whether it is a deposit for a wedding booking or a sitting fee for a portrait session.

◄► *(left and facing page)* It's great when subjects love their images and order lots of big prints, but you can't build a thriving, profitable business on the belief that will happen with every single session.

can recoup some of the lost money—but they now doubt your abilities as a professional, so there's probably nothing you can do to make them happy. This is the way to lose money.

When someone reserves your time, they have to pay you—whether it is a deposit for a wedding booking or a sitting fee for a portrait session.

The Customer Isn't Always Right

Some photographers who have never worked with the buying public think, "If they don't like my work, they shouldn't pay anything." That may sound like a good customer service policy . . . unless, of course, you run a business that deals with people's fragile egos in a society where no one is as young, or thin, or beautiful as they think they should be. Let me tell you something: the costumer isn't always right. Sometimes the customer is crazy.

"The customer is always right" is a good road to follow when you sell a standard product. Costco's liberal return policy is a

good example. If, for any reason, you don't like something you bought at Costco, you can bring it right back. This is possible because you are dealing with common products and suppliers that will honor returns. When you return something, the company is only out the time required to deal with the return process.

Photographers fall into a different business category. We are more like plastic surgeons than big-box retailers. We deal with all the emotions tied up in *how someone looks*—or, at least, in how they see themselves (whether or not that has anything to do with objective reality). As photographers, we must do our best to create flattering images of our subjects, but we cannot waive charging someone who is simply in complete denial about their age, or weight, or baldness, etc. No one can satisfy a person with the wrong self image—the man who thinks six strands of hair totally conceal his bald head, or the woman who doesn't think she looks much different at size 24 than she did at size 8.

You get paid for creating professional portraits. If you *don't* do your job, the client should not pay. If you *do* do your job, you should get paid—even if the client is unhappy with the outcome. Like the plastic surgeon, we can make someone look *better* than they currently do; we can't make them look like they did thirty years ago.

Advantages of a Sitting Fee

When people have money invested, they tend to respect the appointment much more than if they don't. People don't cancel or do a no-show when they have prepaid a sitting fee. When someone makes an appointment at my studio, the studio person helping them takes down their credit card number right away. If the client doesn't like giving out their information over the phone, we give them until closing time that day to drop off cash, come by to charge their session fee in person, or pay it on-line through PayPal.

When we didn't have clients prepay for their session, there were days that had up to 50 percent of the sessions either no-show or reschedule! Once we required that sessions be prepaid, the no-shows ended and the only times we had requests to reschedule were when the client was truly sick or had a real

▲▶ *(above and facing page)* Clients who are willing to pay a sitting fee in advance of their session are the clients you want—ones who are serious about ordering!

emergency. Until clients have *their own money* at risk, they will put off any appointments that require money be spent. They might want a photo with grandma, but they will put it off as long as she is still breathing. Once she starts turning a little blue, they will finally make the appointment (and keep it). Okay—again, I'm exaggerating a bit—but that's sometimes how it feels when you are running a business!

Not only does charging a deposit or session fee keep you from losing money on time you set aside, it also breaks up the total charges and gives your work the appearance of being less expensive. Without a sitting fee, all of the costs incurred in creating the portraits have to be added the cost of the prints. Realizing

▲ Clients are most excited about their images right after the session – so that's the time when you want them to order their prints!

that some clients will only order a single portrait, like an 8x10, the cost of each portrait must be increased to offset these costs. Charging a sitting fee allows me to price my portraits a little lower; even if the client only orders one 8x10 (not the dream scenario, but one you have to allow for), they can do so at a realistic price because the sitting fee has already covered the costs of travel and my time photographing them. We'll look at session fees in a bit more detail in chapter 5.

Product Orders

For portrait clients, we take product orders at a viewing session held immediately after the session—before they leave the studio. At that time, the client will pay 100 percent of the total order. Likewise, our wedding contract specifies that any additional portraits ordered for the couple, family, or friends must be paid for at the time the order is placed.

Financing

For clients who are unable to pay for their product order on the spot, we offer a payment program that allows them to make three monthly payments. We charge a finance fee (interest) for this convenience and only deliver the products when the final payment has been made. I am in business; if the client is going to use my money like a credit card, then I will charge the same interest rates. You have to keep the cash flowing into your business and never risk *your* money on a client's bad decisions or procrastination.

Communication Is Key

This all works because, from the first time the client calls the studio, they are made aware of everything they need to know to have a successful session. This includes planning for the creation of their portraits, the total investment they can plan on making, and when those amounts must be paid. If you are a professional services provider that clients trust, they won't have a problem with your business policies.

Many photographers fear setting policies and discussing payment structures. They say it causes tension between them and

> You have to keep the cash flowing into your business and never risk *your* money on a client's bad decisions or procrastination.

▲ A successful session starts with good communication.

Consider Delegating

Your policies are what keep the cash flowing, and cash flow keeps your business running. If you don't have the backbone to talk with clients about your policies and then enforce them, consider having your spouse or an employee take care of these things for you. For some reason, I've found that women tend to be better at addressing these issues than men—they aren't scared to get serious when they know it will affect the bottom line!

their clients. But let's be honest, the only clients who have a problem talking about payment policies are the ones who don't have the money in the first place. If they are planning a wedding or a portrait session and don't have the money *today*, why would anyone assume they would have money *tomorrow?* This is the payday loan mentality. If your expenses are more than your income, a high interest payday loan is only going to make the problem worse. The same thing is true when planning a wedding or portrait session; if you are broke today, you will be even broker when you're planning these events! If you set your policies correctly, however, you will weed out the people who can't afford your services to begin with. They will have to go to that spineless photographer down the road—the one who hopes they will *someday* have the money to pay him.

If you are honest with yourself, you will find that most of the problems you have in your business stem from a lack of communication at the start of the process. The clients didn't know something about your business or you didn't know something about them. This is part of why it's critical to establish company policies—both for pricing and ordering procedures as well as for planning their session. Having and communicating these policies ensures that you and the client each get what you want out of the session, and that you do it with as few problems as possible.

▶ *(facing page)* When the communication between you and your client works well, you'll each get everything you want from the session.

When Problems Occur

When problems happen (and they will), be firm but reasonable about enforcing your studio's policies. Don't be grouchy—but don't be a pushover, either. The best way to set the policies for your business is to sit down and look at every common problem that you have with clients, as well as any problems your clients have with you.

Bad Checks

If someone has written you a bad check, they have made you incur charges from the bank. They have affected your cash flow and they should pay you the standard $35 fee that most businesses charge. Don't be vengeful and charge them $50; don't waive the fee if the client complains.

Late Payments

I believe in *bending* the rules. If a client owes the deposit on a wedding that is over a year away, yes, I will hold the date for a few days—but at the first sign they are stringing me along, that date is off the books.

Extra Photo Requests

I will also bend my policies about the number of photographs I take. If I am doing a family portrait and they ask me to take one extra idea that I wasn't planning on, I will happily accommodate this request. However, to avoid wasting time and money, I have an established policy that outlines how many family groups we will be shooting and the extra charges that will be incurred if anyone would like an additional image of their individual family. This heads off any problems with the one person (at virtually every event) who wants to make sure *every possible combination* is photographed—down to the two Chihuahuas from different families. They're not paying the bill, so they're not in charge.

When problems happen (and they will), be firm but reasonable about enforcing your studio's policies.

3. Costs and Overhead

At this point, I know that some of you are about ready to scream, "I just want to know how much to charge! I don't need to know all this other stuff!" But without an understanding of *why* you charge what you charge, you are only guessing at what to charge—or following others who don't know why they charge what they charge, either. It's no way to run a business that you want to be your long-term career and primary

◄▼ *(facing page and below)* How many hidden costs are associated with creating each image? Conducting each session? Delivering each product? Probably more than you think (or are accounting for in your pricing!).

source of income. The first step in the process is determining the cost of *everything* involved in producing the products you sell.

Time

Time is a billable and real expense. That's hard for a lot of new photographers to grasp. Even more challenging is deciding how much that time is worth.

Hourly Rates vs. Hourly Wages

You can't compare the hourly rate you charge for your time as a service provider with the hourly wage you'd earn at a regular job.

I've heard photographers say, "Starbucks pays $10 an hour, and I made $30 an hour!" The difference? When Starbucks (or any other job) hires you, they are buying your time *in bulk*. They pay you $10 an hour, but they buy

▲ I figure that every time I push the shutter button, it actually costs me about $.30. It may not sound like much . . . until you multiply all those extra shots per session out over a month or a year. Then it really adds up.

eight hours of your time. They pay you when you are incredibly busy, but they also pay you when you are standing around waiting for the next customer. They also cover a variety of expenses (workman's compensation insurance, etc.) and their commitment saves you the cost and effort of having to go out and look for a new job to hire you every day.

When a client hires you as a service provider, they are buying the time they need, nothing more. Accordingly, your hourly rate needs to *at least* double or triple to include all the overhead (travel, insurance, marketing, billing, setup, etc.) you're shouldering. This is the difference between an employee and an independent contractor. If you hire a bookkeeper as a full-time employee, you will pay them $15 an hour, maybe a little more. If you hire that same bookkeeper as an independent contractor and have them work *only* when you need them, you'll pay a lot more per hour.

I have often said that if I have a camera in my hands, I bill at least $300 a hour; if I am at the computer, I bill at least $50 an hour. Now, I don't actually work on the computer—but most of the young guys that work on the computer for me make $10 to $12 an hour. I mark up what I pay them by 4 to 5 times. Why? Sure, that $10 an hour wage seems like a straight-forward expense. But in addition to the $10 an hour I pay, I am also responsible for their payroll taxes, workman's compensation insurance, paid leaves (as required by the state), and any other benefits or any reimbursements I choose to offer. As a result, a $10-an-hour employee costs me $14 to $16 (or more) per hour.

Time Management

I've mentioned this already, but this is a good place to emphasize the importance of *not* overshooting. I figure that every time I push the shutter release button it costs me $.30. So how much would your overshooting cost you for just one wedding? Or a large family session? Now, multiply that by the number of clients you have in a month or a year. For many new photographers, I'd bet that amount is close to—or even exceeds—how much they truly profited from their business.

I take five to six shots of each different pose; three or four smiling and the last two with a more subdued expression (be-

How Much Is Your Time Worth?

This is a question you have to answer before you even *think* of setting the prices for your photography. This question is two-sided and much deeper than most photographers think. The two sides are:

1. How much are people willing to pay for your time?
2. How much do you have to charge to make a living?

For many photographers, calculating the time involved in the creation, editing, and delivery of their work is too difficult a prospect to even consider. This is why so many people in this industry default to basing their prices on what other photographers charge (hoping they know what they are doing) or come up with some magical formula, like charging ten times the lab costs.

Time is the missing factor in most photographers' pricing strategies—even those of more established studio owners, who sometimes invest so much of their time into working with each client that they have to sell thousands of dollars in portraits to make more than minimum wage. Another problem is that we photographers tend to have large egos; we think no one can do the job like we can, so we tend to try to do as much of each of these jobs as we can—which is just plain stupid!

I can generate up to $1000 and $2000 an hour in sales when I have a camera in my hands. The minute I move from the camera to the computer, my value has just been reduced to about $15 an hour. If you insist on editing your own work, you have to either give up profit (sitting at a computer when you could be shooting) or give up your home life (working when you should be spending time with your family).

To keep your time investment under control, you also have to monitor how much time you spend with each person—keep it to a minimum, but without making the client feel like the experience wasn't personal. In lean economic times, this is not only a good way to ensure your profit; it can also help you keep your prices competitive. I spend 45 minutes to one hour, total, with each senior I photograph. Between employees and a streamlined business system, that is my total investment of time. This means I can photograph more sessions per day and keep a steady stream of people coming through my door. That ability to boost my volume is very important; today, large orders are still happening, but less frequently than they did a decade ago. Seeing more clients is a way to make up the difference.

While time is only one of the factors involved in your pricing, it is the one factor that most photographers don't want to address—probably because it makes them be responsible with the use of their time and seem less artsy! When all is said and done, though, you only have so many hours to work this year. Every hour you spend on the computer, shooting too many images and editing down, and dealing with things employees could do for you is an hour you're not maximizing the profit that will end up in your pocket.

cause smiling photos outsell non-smiling one by a ratio of at least three or four to one). Why would I take twenty shots like a machine gun and then spend money to have someone edit those images back down to five?

Some of you are thinking, "Well, it's so I capture the perfect image!" I'm here to tell you that the "perfect" image actually results from making smart decisions as you set up everything—before you ever take the first photo. It's a result of seeing things with your eyes, not pushing a button with your finger. For those

of you who are freaks for expression, the subtle differences between all the smiles, I have news for you, too: at most of my viewings, the clients don't even detect those minute changes between the photos. More often, I have to point out the slight differences in the size of the smiles and how that expression affects the face (eyes, wrinkles, teeth, etc.).

So if you're justifying overshooting on the grounds that you have to do it to get a perfect image, you need to get over that. Put a little extra time into planning. Fine-tune your eye for detail and work on getting the *right* photos, not just *a lot* of photos. To be brutally honest, most of the bad business decisions that photographers make are based on their own feelings or to justify behavior they don't want to change.

▼ Great images should be the result of solid planning – not overshooting until you happen to get a good shot.

Equipment Costs

Here's a business lesson I learned early on: if you watch the pennies, the dollars take care of themselves. And, trust me, I watch all those pennies! In an average year, I *save* more by controlling and monitoring costs than many photographers *make*.

Equipment costs are one area where that's especially true. If you have read my books, you know that I buy equipment and wear it out. Only then do I buy new equipment. Photographers waste so much money on updating equipment for no reason other than the way it looks. I had one wedding photographer at a program tell me that he couldn't have the guests at the wedding show up with a better camera than what he had. *Really?* A profes-

Photographers waste so much money on updating equipment for no reason other than the way it looks.

◀▶ *(left and facing page)* Do you absolutely require expensive, state-of-the-art gear to create your images? If not, why would you spend money replacing older gear that is still doing the job you require?

sional photographer is a professional because of what he knows, not what tools he uses. Give me an old 35mm camera and a manual focus lens and I will create beautiful portraits. On the other hand, you can put the most expensive, state-of-the-art camera and equipment in the hands of a young photographer with little training and end up with worthless junk—the same poor images they would have shot with the cheapest camera or lighting system. Professional photography is about *knowledge* not *equipment!*

Cameras

Over the course of my 25-year career, one practice alone has saved me a huge amount of money. Want to know the secret? I only buy new equipment when my current equipment wears out, or when buying the new equipment will allow me an opportunity to make more money. While most photographers update their camera about every three years (on average), I currently have cameras that are over seven years old—and going strong. When I did choose to update my digital camera earlier than normal one time, it was because digital technology was newer and still evolving pretty quickly—even the images from professional cameras couldn't produce a high-quality wall portrait. Therefore, when the right technology became available, I replaced my cameras earlier than normal so I could sell larger wall portraits. I knew that I would not only recoup the cost of the new equipment but make additional profits each month from owning it.

Lenses

Now that I've kept you from maxing out your credit cards on the latest and greatest camera, let's talk about lenses. Rather than brand name, what you should be thinking about is focal length. Some photographers select a lens based on the working distance they want between the camera and the subject (for example, I see photographers working outdoors with a normal lens because it allows them to work closer to the client). Some photographers, on the other hand, use a huge a telephoto for no other reason than it looks cool.

The proper way to select a lens is to decide how you want the photograph to look and then select the lens that will achieve that look. As a result, I almost never use a "normal" lens (50mm for a camera with a full-frame sensor). Using a normal focal-length lens gives you the same look that people are used to seeing in the candids they take at home—and people won't pay (or at least won't pay as much) for portraits that look normal in any way. Normal lenses also affect a person's appearance in ways that aren't pretty. Typically, the nose appears larger and the person's head looks slightly distorted.

Some photographers use a huge a telephoto for no other reason than it looks cool.

▼ What's the right lens? The one that minimizes distortion and creates the perspective you want in your image.

▶ The brand of light or modifier you use isn't important – what matters is that your light sources produce consistent results.

Will a more expensive brand of lighting make your subject look better? I think not.

A better choice for almost all portrait photographers is a lens in the 100mm to 135mm range (be sure to take into account the focal-length factor for your camera model). This gives you the best perspective for creating a salable portrait. It isolates the subject, putting the foreground and background out of focus for more impact on the subject and a greater feeling of depth.

Large telephotos (250mm–400mm) are useful when you have a very distracting background you want to throw completely out of focus. But keep this in mind: you are in control of the background you use. A beautiful background adds to the overall look of the portrait, so if you find you have to use a long telephoto to throw an ugly background completely out of focus, you're probably better off moving to a more attractive spot to create your portrait.

Lights and Modifiers

Will a more expensive brand of lighting make your subject look better? I think not. That said, certain lighting equipment can make your life easier. Especially for digital, life is easier if you work with a single brand of lighting in each camera area. Each brand of lighting produces a unique color of light; they may all be close, but they're never exactly the same. White balancing your digital camera is much easier when all the lights produce the same color. I have twelve shooting areas and just about every light known to man. To make my life easier (and avoid having

to purchase more lighting), I grouped the same brand of lights together in each camera area, creating a consistent color within that area. This can also work with smaller studios; simply group the same brand of lighting for your main and fill, then use the other brands of light as your hair and background lights. This way, all the lights that determine skin tone will produce the same color temperature.

Make Purchases Based on Results

Equipment should be selected to achieve the desired results. Don't select a lens (or a light, or a camera, etc.) because it looks cool or because it's the one used by another photographer. Select the equipment you need to achieve the results you are looking for. This type of thinking is what separates the creators (who control everything in their images) from the copiers—and the photographers who just don't care.

Once you've decided what equipment you need to do what you want to do, you can go on to consider how much you want to spend and how durable the equipment is. When you look at

This type of thinking is what separates the creators from the copiers.

▼ ▶ *(below and facing page)* Instead of buying a new backdrop, why not scout for a new location instead? This patch of foliage in a business parking lot (see the pull-back image at the bottom of the facing page) is beautiful and free!

equipment purchases, remember that you will only make so much money this year in your business—so how much you *spend* will determine how much is left over to live on.

Finally, you don't need seventeen backup pieces of equipment. You need one camera and one backup camera for each camera area (or photographer) you have. You need one backup light for every camera area—and that's it! If you do weddings, you may need an additional backup—but you still don't need six or seven camera bodies "just in case." If you have more equipment than you truly need, sell it and invest in learning how to use the equipment that's left.

Learn to Use What You Have

I am not trying to put equipment manufacturers out of business here. I am just trying to get you over the thinking that equipment in some way makes you a better photographer—because it doesn't. It's knowledge, not equipment or gadgetry, that will make your images beautiful. The point here is simple: shoot with what you have and get better at using it.

Buy new equipment when your old equipment no longer works properly (or your repair bills are too high) and only buy what you need. If you shoot beautiful portraits with an old 35mm camera and your clients don't order sizes larger than 11x14 inches, you're all set! If you find that your clients want larger sizes than you can produce with your current equipment, then you have a reason to upgrade your equipment and a way to pay for the upgrades.

Many photographers struggle financially, and often it's not from a lack of opportunity to make money but because they squander money on things they really don't need in the first

◄► (left and facing page) An extensive roster of free, convenient locations can help to increase the variety of your work while lowering your costs.

Every dollar you spend is a dollar you take away from the lifestyle you can provide for yourself, your spouse, and your children.

place. When you run a business, you must protect your profit at all costs. Every dollar you spend is a dollar you take away from the lifestyle you can provide for yourself, your spouse, and especially your children. I hate seeing photographers try to justify buying a new camera when their children need new clothes and shoes for school. *Really?*

Regularly Review Your Costs

Once a year, I have my bookkeeper review everything to find if there is a cheaper product or service of the same quality we

currently receive. I continually check suppliers to ensure I am paying a fair price. I also look at my current business practices and see if other business practices would be more profitable.

For many years we had our own digital lab, complete with a chemical process printer for everything up to 11x14-inch prints, and a wide-format inkjet printer for larger prints or printing on photographic canvas. As our large printer aged, we had to look at the costs of keeping the older printer and maintaining it, buying a new printer, or going with an outside lab. When I looked at the costs of electricity, maintenance and repairs on the printers, papers and chemistry costs, and chemical pick-up—it was all very close to the volume discounts I'd now receive when having an outside lab print my work. While running our own lab had made financial sense for us earlier in the evolution of digital technology, it was a lot of work and worry. At the current prices and quality of printing, I decided the quality control and savings were no longer sufficient to offset all the work.

You must look at every opportunity to lower your costs. If you have sessions cancel for an afternoon, send your employees home. If you worry about losing key employees, ask them if they would *like* to go home—most of the time, they will gladly take off early. Power-down the studio lights if you aren't using the studio for periods longer than thirty minutes. Put a lock box on the thermostat if you have employees, whether you work out of your home or a studio. In every office in the country, there is a war that wages daily over the climate control. Set the thermostat where it should be, as suggested by the power company for maximum efficiency, and then lock the box. And use a programmable thermostat so you're not heating or cooling your space when no one is there. I can't count the number of times an employee set the heater to 80—and then forgot to turn it off when they left for the weekend. This is wasted profit!

In professional photography, it is difficult enough to make a profit without throwing money away on unnecessary expenses. You should protect profit as though your life depends on it—because it does!

4. Elements of a Profitable Workflow

As photographers, we always seek to increase the expectations of our clients. We talk about quality, style, and elegance—but many of us also promote *how long* we will spend with the client to create their portraits. That is counterproductive to profit and one of the worst things you can do during an economic downturn. And, truthfully, I have seen just as many beautiful portraits come from an hour-long session as from a three-hour session. There are better approaches you can integrate to maximize the client's experience, the results of the session, and the profit you'll generate.

Develop a Style That Clients Want

First and foremost, You have to know what your client will buy—what, statistically, has the best chance of selling. You have to create what sells, not just what feeds your ego.

What All Clients Want

Many photographers spend their careers trying to convince clients to buy images that were created to suit the photographer's tastes, not to fulfill the client's expectations. Successful photographers determine what sells, then learn to enjoy and improve on that style. So what do portrait clients want? Here's a quick list:

Beautiful Eyes. The eyes are the windows to the soul—but if they aren't lit and posed properly, the windows are closed. Somehow, many photographers forget this important concept.

Shadows. We've all seen work by mall photographers or national photo companies, and they tend to look flat. Controlling

Check in With Your Clients

When it comes to developing a style that sells, it can be helpful to show clients examples of your work and allow them to direct you. Keep in mind the bias that parents have when they look at other people's children and when they view their own. You can show a mother a portrait of someone else's child taken with a very small facial size and she will say it is beautiful. Show her the same photo of her child, however, and she will often say the face is hard to see.

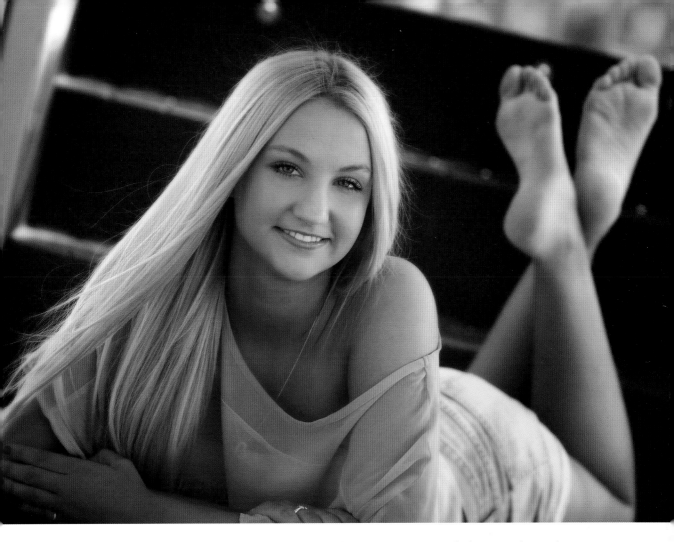

▲ All portrait clients want to see beautiful eyes and nice shadows in their images.

Where do you want the viewer to look first? The answer is the face.

shadows is difficult for the inexperienced photographers who tend to staff these studios, so most companies reduce the lighting ratio to provide little or no shadowing. If light were really our paintbrush, these portraits would be award-winners, because they have nothing but light in them, right?

Contrast. Another common misconception is that our eyes are drawn to the lightest area of a portrait first. In fact, our eyes are drawn to contrast. Knowing this, where should the area of highest contrast be? Where do you want the viewer of an image to look first? The answer is the face (with those beautifully lit eyes we just discussed). Whether the portrait is head-and-shoulders, three-quarter-length, or full-length, the face should be the focal point. This is so important that it bears repeating: no matter what your portrait style is, your first goal is to direct the viewer's attention to the subject's face.

Expert Retouching and Printing. Clients expect images to be free from blemishes, with the obvious lines and under-eye circles reduced to make the subject more attractive. Clients also expect the skin tone to resemble the actual skin tone of the subject (slight darkening for fairer-skinned subjects and slight lightening for darker-skinned subjects is usually acceptable, however). If you let unretouched images out of your studio—and I say this from both an artistic and a business standpoint—you're making a big mistake. Neither you nor the client will be completely satisfied with unretouched photos. Additionally, these sub-par images will go out into your community as representative of your

▲ Basic retouching should be included on any portrait that leaves your studio – and it must be factored into your pricing.

work—and you don't want potential clients to see them and think, "Oh, so that's the best they can do." This reaction isn't going to make them pick up the phone and book a session.

Therefore, clients shouldn't have the choice to skip retouching. Either increase the price of your portraits to cover retouching or make retouching a separate fee the client must pay for each pose they order (they pay the fee only once per image, regardless of how many prints of that image they order). To avoid having unretouched images leave our studio, we added what

we call an "image fee" to most of our packages. This is a charge for retouching the first portrait ordered from any pose. If you decide to charge an image fee, be sure to note the amount (and give a brief explanation) in all your information; you don't want clients to be surprised when they order. Even clients who know about the charge will sometimes ask why they must pay it. We explain that this is the only fair way to charge for this service—after all, we have clients who order an entire package from one pose, while other clients will order from ten different poses. If we included the charge in the print price, we would be overcharging the clients who ordered from a single pose. We also have inclusive plans that have this fee built into the cost.

When it comes to printing, some photographers prefer a natural skin tone, with no additional colors or saturation added; other photographers like a rich, colorful skin tone. There is no right or wrong, just personal preference, but you had better make sure that your clients have the same taste as your own. Whether you print in your studio or continue to work with a lab, how you adjust your files and deal with color management issues will greatly affect the skin tones in your final prints.

Tailoring the Shoot to the Individual's Needs

To succeed in portraiture, you need to do the things all clients want—but you also have identify what your specific client expects from the session. This includes understanding both the intended audience for the images and the subject's expectations for how they will be presented in their portraits.

A Portrait That Suits Their Purpose. Imagine that a young woman comes to your

Bigger Faces Mean Bigger Sales

Scenic portraits, those with a small subject against a large, beautiful background, have become more popular in the last few years—at least in terms of what photographers talk about and display. I can appreciate the beauty of a scenic portrait showing someone else's family . . . but when it's my loved one, I'm going to have the same complaint most clients do: "I can't see their face!" (This is usually followed by ". . . and I'm not going to buy that.")

I am not saying that you should ignore clients' requests. My photography has always been and will always be directed by what my clients truly want and buy. To allow your photography to be directed by anything else is futile in a business structure. However, you must also realize the natural tendencies of your clients and take close-ups along with any scenic. Offering some shots with an increased face size will ultimately make the client happier and increase your final sale.

Unfortunately, I have a sneaking suspicion that the proliferation of scenic portraits has less to do with satisfying clients than with making the photographer's job easier. With a smaller face size, the quality of the lighting is less critical—in fact, with a sufficiently amazing skyline, people might not even notice that the lighting on the face is actually pretty bad! If you truly have all your clients plunking down their hard-earned money for large wall images of scenic portraits (large enough to really see the faces), then I say keep doing what you are doing. However, if you are hiding the faces in the landscape to disguise the fact that you're not in control of the lighting, you're headed in a bad direction.

studio for a session. All you know is she wants a portrait of herself. Without finding out the purpose of the portrait, you are shooting in the dark. She might want a business portrait, a portrait for her husband, or an image for her grandparents. Even when the client defines the purpose of the portrait, you should ensure you're both on the same page. Adjectives like "sexy," "happy," "natural," and "wholesome" represent different things to different people. Before you decide how to photograph someone, you had better understand what these things mean to them.

A Portrait That Minimizes Their "Problem Areas." Almost every person has something in their appearance that they would change if they could. Accordingly, most clients will not buy a portrait that simply records them as they are. We all live within a standard of beauty set for us by our culture—by the models and actors used in our fashion magazines, advertisements, television programs, and movies. That is the benchmark to which most of us compare ourselves. However, most of us don't look quite like the "ideal."

▲▶ *(above and facing page)* Before you photograph a client, you have to know what they are looking for in their images – and, ideally, what aspects of their appearance they might want emphasized or subdued.

Most clients will not buy a portrait that simply records them as they are.

Statistically, for example, we know that most Americans are overweight. Yet, a slim appearance is part of today's standard. If you could make your clients' faces and bodies look thinner, more in keeping with the standard of beauty, don't you think you'd have a greater chance of selling your images? In my experience, 97 percent of portrait subjects (even ones who are already trim) would like to look slimmer. Therefore, my posing and lighting styles tend to focus on achieving that objective.

In my experience, 97 percent of portrait subjects (even ones who are already trim) would like to look slimmer.

◄ Whether they are trim or full-figured, virtually all portrait clients appreciate images that make them look thinner than they are.

Basically, the portrait has to match how your subject would *like* to look—and how they probably do look in their own mind. Our subjects' self-images can work against us as photographers. This is especially true with a subject whose appearance has been transformed by the gradual effects of aging. How many men do you photograph who are nearly bald but act surprised when they see "some bald guy" in their family portrait? How many women have you photographed who now shop at the larger-size clothing stores but seem surprised when their portraits don't show them looking like they did in college? As we age, our minds protect our egos a bit, preventing us from having to deal with the real image of ourselves. You can't sell a portrait if the subject's depiction in it doesn't match (or at least come close to) their self-image. Self-image makes your job as a photographer much harder, because it is not your perception of the client that matters, it is the client's—unless, of course, you don't care about money and profit!

I've said it before, and I'm going to keep saying it: there's no point in producing a product that no one wants to buy—or doesn't like enough to purchase at an adequate size for them to enjoy on the wall (and at an adequate profit for you to earn a good living).

Improve Your Communication with Clients

I have spent a great deal of time training my staff to obtain all of the aforementioned information from clients and pass it along to me as seamlessly as possible. Having all this information up-front allows me to maximize every moment I spend with the client—which is a driving factor in increasing the profit from a session.

Collect Information

We have an information sheet filled out for each client, listing the reason the portrait is being taken, for whom the portraits are being taken, who will be in the portraits, and the basic tastes of all of the listed people. Our staff members then ask specific questions to get clients talking about their ideas and what their perfect portrait would look like. They also bring up the fact that many people have concerns about their appearance and that there are many ways to hide, correct, or soften problem areas *if we know about them*. One way to get people to open up is to ask questions that require only a yes/no response. For example, instead of asking them to list their least favorite features, you could say, "A lot of women worry about the size or shape of their nose. Is this something that concerns you?"

Additionally, we have each client look through sample books targeted at the types of images they are taking. They select the ideas they like the best and my assistant writes it all down.

The client sheet is put into the client envelope and, while the client is shown into a dressing room, one of my assistants relays that information to me. At this point, I know the purpose of the portraits and who they are being taken for. I have a basic understanding of the tastes of the people involved and the ideas selected from the sample books. With all this information, I now have a clear idea of how to design images that are well-suited to the purposes of the client.

This is the missing step in most photography businesses. I am good, but I can only create what the clients wants if I know what it is.

Implement What You Learn

Clients are paying for your expertise, so when you see someone has made a choice that isn't in their best interests, you need to guide them in a better direction. This could involve a new image concept, a wardrobe change, or a different composition—whatever results in a more flattering and salable portrait.

Often, clients love a sample portrait but then hate how they look in that same pose/setting. You can usually solve this problem before it starts. For example, if a bride with short hair selects an inspiration image of a bride with long hair blowing in the wind, she will likely be unhappy with a direct re-creation of that image. Instead, think of ways to modify the overall look to fit her unique situation and be honest about the changes. ("With your short hair, it would be hard to create exactly the same look—but I have some ideas to get a similar feeling . . .").

Be creative and choose your words carefully. For every problem and potentially embarrassing situation there is a way to handle it without making yourself look unprofessional or seeing your client turn red. Most importantly, handling it (rather than

> Think of ways to modify the overall look to fit her unique situation and be honest about the changes.

◄▲ *(facing page and above)* You have to understand your clients and what they want. What works in one business and one area may flop in another.

avoiding it) will put you on the path to creating portraits the client will thank you for—and buy!

Understand Your Unique Demographic

Now, it's time for a disclaimer. We've looked at some of the things that portrait clients, across the board, tend to look for in professional photography. However, *what works well in one area doesn't necessarily work in another.* There are differences in clients' tastes and beliefs, the population of the city or town, and countless other factors to consider. I have tried many ideas during different stages of my business—things that seemed like a great

idea when I learned them at a seminar but then flopped when I tried them at home. You can't rely on photographers who know nothing about your business or your potential clients to guide and direct your studio. Take in new ideas wherever you may find them, but then filter those concepts through your own experience, judgment, and knowledge.

Learn to Be Consistent

Once you've learned what your clients want and will buy, you need to work on producing that in every session. Unfortunately, many young photographers have a hard time seeing the line between "consistent" and "boring."

As you start out in photography, the one thing you don't want to become is one of those "old guy" photographers. You know the ones I'm talking about—they've been shooting since the day after the camera was invented and they gave up on improving their photography years ago. Now they just want to keep cranking out photographs so they can make as much money as

▲▶ *(above and facing page)* Once you've learned what looks your clients want to buy, you need to establish consistent approaches for producing those looks at every session.

Many young photographers have a hard time seeing the line between "consistent" and "boring."

possible before they seize up and meet their maker. No young photographer wants to be that "old guy." In fact, I don't think any photographer wants to become that "old guy!"

Being consistent doesn't mean you quit learning and evolving. I have been photographing for a few decades now and my work changes each year. I try new ideas and concepts; I weed out the ideas that have come and gone. Imagine that you are the chef in a fine restaurant. Naturally, you try out new recipes to keep your menu up to date and give people something new to sample. The dishes you serve day in and day out, however, will be crafted in such a way that they taste the same whether a patron orders them today or a year from now. Imagine a diner comes in on a business trip and orders your delicious venison in a cherry cream reduction. He loves it and can't wait until his schedule brings him back to town to enjoy it again! When he returns, you can bet he'll be disappointed if it doesn't taste like he remembers it. That kind of consistency is what diners expect from a premier chef. It is also what your clients expect from a premier photographer.

Master Previsualization

The best photographers use their minds; the weakest use their cameras like machine guns—shooting countless images until something happens to look passable. Machine-gunning (just shooting away and hoping for the best) is the easiest way to ensure you never learn photography. When you are new to photography, this planning process takes time, but unless you start using and developing these skills, you will never improve.

My photographic process is as follows with each client. First, I look at the client as I greet him or her. I look for problems like weight gain, thinning hair, uneven eyes, sagging skin, etc.—things that need to be minimized or softened. I then help the client select the clothing that will work best to conceal any area they will not want to see in the photograph (things that, if visible, will keep them from buying the photographs). As they are changing into the clothing I selected, I begin visualizing how to pose them to look their best and hide as many problem areas as possible while still creating the look or style they desire. From there, I choose the lighting, background, and camera height that best suits the client's individual needs. At this point, the portrait is created in my mind. I then tell my assistant where everything goes and what background or scene to use. When the client comes out of the changing room, I show him or her the pose, help them into it, and adjust the lighting to them (in the pose). I then take a second to look for any problems with things showing that shouldn't (bra straps, zippers being down, bulges that shouldn't show, large arms, hair showing on a woman's forearms, etc.). After addressing these issues, it's finally time to pick up my camera and photograph the client.

I use my mind and my skill to create an image; too many photographers today only seem to finally engage their minds when it comes time to edit through hundreds of crappy images to find the few (accidentally) good ones. As a professional photographer, you can't do photography by guessing or rely on "art by accident."

Plan Your Portraits

Many young photographers think that not having a plan during a session is artsy and cutting edge. Really, having a plan shows that the photographer has developed the skills to envision what the image will look like. When you give yourself an hour to create a client's portraits, you'll find that you put a lot more effort into fully developing the portraits in your mind. You know you won't have time to mess around and hope you stumble into the "right spot." You plan, you know, you think. When you finally pick up the camera, the portrait has already been created in your mind and recording it as an image file is just the final step.

Way too many photographers use the camera as their brain and the law of numbers as their creativity. They just start shooting and moving, and hope there will be something good for the client. That is not professional photography; that is an attempt to get around learning the process of photography. While you might think you have saved time, you have created a workflow that will not sustain a profit—at least not enough of a profit to live on.

Practice—But on Your Own Time

At every location where I shoot portraits for clients, I have developed the specific background areas I will use at different times of day. I also spend time learning the best poses for each scene. These are things that I practice shooting and experimenting with *on my own time*, so I can provide clients with images that I know are the best images I can produce. Everything is planned and known before the session ever starts. I don't care how good a photographer you are, *no one* is good enough to provide a

▲ Set clear limits on the session – so you have enough looks and variety for the client, but not so many that they are overwhelmed or that you have to spend endless hours sorting and editing.

client with nothing but salable images when they're working on the fly. There will be a few salable images and a whole lot of garbage. Best of all, a strategic approach like this makes working at an outdoor location just as quick and easy as working in the studio—while providing clients the same variety and quality.

Know That Limits Boost Efficiency

Before you ever start a session you must know how many images you are going to take, how many clothing changes you will allow, and how many scenes/poses you will take. Without a clear limit on each, you will waste time overshooting and, later, editing down all those images.

All of my sessions are based on eight images; that's because we photograph seniors and most senior products feature, at most, eight images. Sessions come with eight pose changes; this means that, in each of four basic scenes, I'll shoot a close-up and

a three-quarter- or full-length portrait—giving me eight different looks for the client to choose from. For each of these eight looks, I'll shoot about six frames; four smiling and two to three with a more subdued expression (because smiles are our best sellers). I don't take more photos than that—period. If something doesn't look right for my subject, I stop and put them into a different pose or scene. I don't just continue to work with a pose or a scene that isn't right to see if they like it and then take more photos to select from.

Conflict Avoidance Is Not a Workflow Strategy

The workflow strategy of the average photographer has much more to do with conflict avoidance than making a living. They bend over backwards to solve every little problem and wonder why there's no money in the bank! Want to ensure you never turn a profit? Here's how: start by overshooting—allow clients to add endless groupings that were not discussed when they were hiring you, or say it's fine when they want to change one or two extra times because they didn't get to wear their two favorite outfits. When you see problems or flaws through the camera, ignore them. Then, allow the clients to leave the session without placing an order. Finally, sink hours into over-enhancing their images—because you can. Doing any of this will basically ensure you never make a profit.

Communicate Your Policies Clearly

The key to success and a profitable workflow isn't to give your time and talent away, but to give each client all the information they need about the exact way you do business.

Come up with a price to cover the additional time you'll spend if they want extra images or an additional clothing change. List your fee for additional hours at a wedding so the bride knows how much it will cost her to put off the "cutting the cake" photos for two hours while you sit around doing nothing. If Mom wants to look as though she has a size 5 shoe or a size 6 dress, she should know that those kinds of enhancements

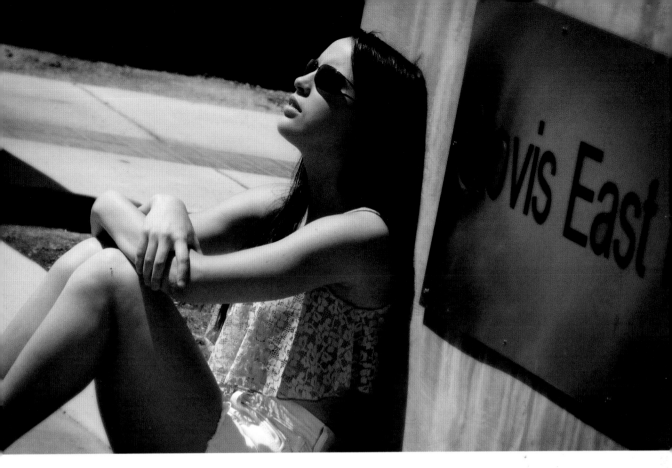

◀▲ *(facing page and above)* Give each client the information they need to make the session a success.

You can avoid conflicts, and protect your profit, by going over your policies in the very beginning.

are not included in your standard fees and will be quoted at the time of the order.

Put *all* of your policies in writing—especially those on pricing—and go over them with each client. Most of the problems you'll ever encounter with clients aren't a result of their unwillingness to pay for things, they're a result of the client feeling surprised by "extra" fees. Too often, photographers fail to go over their policies in detail—until they finally get mad about how much of their time the client is "wasting." Then, after they have been waiting around for two hours to take the "cutting the cake" photos, they ambush the bride with what they'll be charging her for the extra time.

You can avoid conflicts, and protect your profit, by going over your policies in the very beginning. Customers value the experience of working with companies that have a structured way of doing business. It is a sign they know what they are doing—and that they are honest and upfront about the way their business runs.

The Bottom Line

I know what you are thinking: "All I want to know is how much do I charge?!" If you follow my suggested workflow, as detailed throughout this book, you could profit by charging as little as $20 for an 8x10. If, on the other hand, you decide to make all of the potential workflow blunders—if you do not establish a profitable workflow, communicate it clearly, and then follow it with each and every client—you could actually *lose* money charging $100 for an 8x10!

Sell Immediately After the Session

Like it or hate it, the best sales come when the client is the most excited to view the images, which is right after the session is over. Therefore, I shoot to be able to view the images right after the session is over. The number of photos I take (and *don't* take— you confuse clients with too many choices), my lighting, posing, composition, and framing are all chosen to provide me the best chance of making a large sale.

Get It Right – In the Camera

Pretouching, editing the images before the client viewing, really isn't necessary if you photograph your subjects properly. In the days of film, photographers created images that were 95 percent as good as the final, retouched image would be—and clients ordered even wall portraits with the understanding that the final images would be retouched. If you can't sell your unretouched images to clients, you don't put enough into your photography and rely too much on the computer to make up for your shortcomings. So fix it!

Minimize Post-Processing

To maximize your profits, computer work or enhancement should be done according to established guidelines for *every* image. You can end up giving every bit of profit away by spending way too many hours retouching each client's images—or having to price your work so high that no one can afford it.

My digital retouching workflow is exactly the same as it was when I had my negative retouchers working on film. They

▲▶ *(above and facing page)* When you take the time to find nice lighting in a good location and refine the pose, your images should look really good straight out of the camera.

simply remove or soften acne, lines, circles, and wrinkles. Then, I have them slightly brighten the eyes—and add a little color if the person's makeup is flat. That's it, folks! If any other enhancement is requested, the client will be paying for it.

The reason I am able to do this comes back, again, to having a plan and shooting carefully. Most of what photographers spend hours correcting are issues that should have been fixed before the photo was ever taken; some of it is the result of clients wanting perfection in a less-than-perfect world. I have heard of a photographer making a lady's feet look smaller and even putting nail polish on her toes—without charging any fee to cover his time! You can't do that. You have to make money every minute you or an employee is working. That money either has to be figured into what you charge for every print (hard to do for nail art!) or you have to charge a fee for these additional enhancements.

Select the Correct Lab

Another important workflow decision is choosing a professional lab to print out your photography. For those of you who are established, this section may be unnecessary—but many newer photographers don't understand the need for a *professional* lab.

While many photographers today use consumer labs, like Costco to print out "professional portraits," consumer labs are really designed to print out snapshots on the cheapest paper, using the least expensive process. Professional labs use paper that is thicker and typically employ more silver in the processing.

Control Imaging Costs

I clearly remember the first time I saw a person demonstrating digital retouching. The image was a full-length bridal portrait, with the woman shown holding her veil in each hand. The hands were exactly the same on each side of the body—perfectly symmetrical. The person doing the demonstration explained that the image would be better if the one arm was bent with the hand coming upward, while the other arm stayed extended down.

The fact that digital made this correction feasible is all fine and good, but shouldn't the photographer have posed the bride properly in the first place? Also, who paid for the time to remove the bride's arm and reposition it? As one of the characters in *Jurassic Park* said, "You got so caught up in what could be done that you didn't think if it should be done!"

Today's imaging technologies have given us amazing options, but each one of them takes time—time that has to be paid for. If you can't get your images the way you want them in your camera (aside from simple retouching for acne and other blemishes), you need to quit spending so much time fiddling on the computer and work on developing your lighting, posing, and shooting skills.

Many newer photographers don't understand the need for a professional lab.

This results in richer colors and better skin-tone reproduction than consumer-grade papers can offer. The cost of a professional lab is higher, but this is one time it is money well spent.

Some young photographers have told me that they feel intimidated about dealing with a lab that works with larger studios and established photographers. I can reassure you: labs realize everyone has to start somewhere. They only care that you are happy with the print quality and that you pay your bill—they're not worried about your experience level. Establish a good partnership with your lab. They can help you establish an efficient workflow and ensure proper color calibration, which increases profit by reducing remakes that you have to pay for.

Professional labs also provide finish work, such as mounting, spraying, and texturing your photographs. Some labs also offer inexpensive framing for common sizes of wall portraits (11x14, 16x20, etc.). Framing is an important part of selling wall portraits (as is, in my opinion, including a readable watermark or logo to turn every wall portrait sale into a billboard for your work). Without a frame, most wall portraits get put into a closet while the client waits to remember to look for a sale from the local framing companies . . . which means it is going to sit in the closet for a long, long time. If the lab you decide to work with doesn't offer simple, inexpensive frames, I recommend checking out Levin Frames (www.levinframes.com).

5. No Simple Solutions

In the beginning, a photographer must establish a basic price for each product they sell to ensure profit and safeguard against loss. Simply not losing money and turning a profit on each client is a major step forward for many young photographers. The ability to charge *more*, especially while giving the impression that your work is very affordable, is a good thing. It's the next step toward making a good living as a professional photographer.

The Profit Profile

Once you establish pricing that ensures a profit, then you can begin working toward the next level of pricing. At this level, you understand and are prepared to manage every aspect of the profit profile: pricing, costs and overhead, cash-flow, volume, workflow efficiency, and profit planning. As we've discussed in the previous chapters, these each represent a facet of your overall success in business. Which photography company will be the most successful? Obviously, it's the one that can charge the most and have the highest volume while controlling the costs and overhead and operating a profitable workflow system. This has little to do with the quality of the photography. There are many very profitable photography companies that create nothing more than a roadmap of the human face—but they understand how to run a business and create a large demand for their limited supply.

Consider ALL the Variables

If you think about all of the variables in the profit profile, one thing will quickly become clear: each photography business has

Simply not losing money and turning a profit on each client is a major step forward for many young photographers.

a unique set of circumstances that determine how much they have to charge. That makes it impossible for me to tell you exactly what your 8x10 price and sitting fee should be. I guess I could throw out a number—but my goal in this book is not to make it easy and let you fail. I want to make it real and *help you succeed*. Simple solutions are for lazy people who don't want to take the time to become successful.

Is your photography business you working out of your home? Or is it you and three employees working out of a commercial studio location? In each business structure, there is a huge difference in the break-even amount that needs to be charged for an 8x10. With my larger studio, and based on the average number of hours we worked each month, I had to generate $300 an hour in sales to turn a profit. Achieving that amount required a balance of business skills. I used marketing and advertising to keep the books full during the hours we worked; I implemented an efficient workflow that didn't eat up the profit; and I used a photography sales system that increased the amount of each order.

More on Sitting Fees: Some Practical Examples

Let's look particularly at session fees as an example of how complicated it can be to calculate the right pricing for your services—and the price you'll pay if you *don't* make this effort!

Say, after reading chapter 2, you are convinced of the necessity of charging a sitting fee . . . but you don't really like math and keeping track of your business. If that is the case, charge your clients a $500 sitting fee! That way, no matter how poorly you run your business, you probably won't *lose* money. The downside

is that you probably won't have many customers—so you won't *make* much money, either.

There is no one who can magically give you the perfect value for *your* sitting fee. It all depends on your business and what you offer. It may not even be the case that *one* fixed sitting fee value will cover all the things you're asked to do. Let's consider some examples.

Location Sessions

I book most of my outdoor sessions in a park that is two minutes away from my studio, with a limited schedule so I can do at least two or three consecutive appointments at the park. This minimizes my drive time and setup time, so I can charge the same sitting fee for outdoor sessions as studio portraits.

However, some clients request portraits in a different location, usually one that is special to them. While I am happy to do this, I have to charge for the additional driving and setup time at the same rate as if I were photographing a session (because I could be shooting an additional, profit-generating session rather than sitting in the car). Considering that, typically, I have never been to this location and I am completely responsible for the quality of the images from the session, I also have to visit the location before the day of the session to make sure it will work. This is another added cost to the client.

So when potential clients ask about going to an outdoor location other than this park I respond, "You can go *anywhere*—but if you do your session at our outdoor location, it is the

▶ *(right and facing page)* At a park near the studio, I can create a wide variety of looks in a short time – meaning I can offer location sessions here at the same cost as studio portraits.

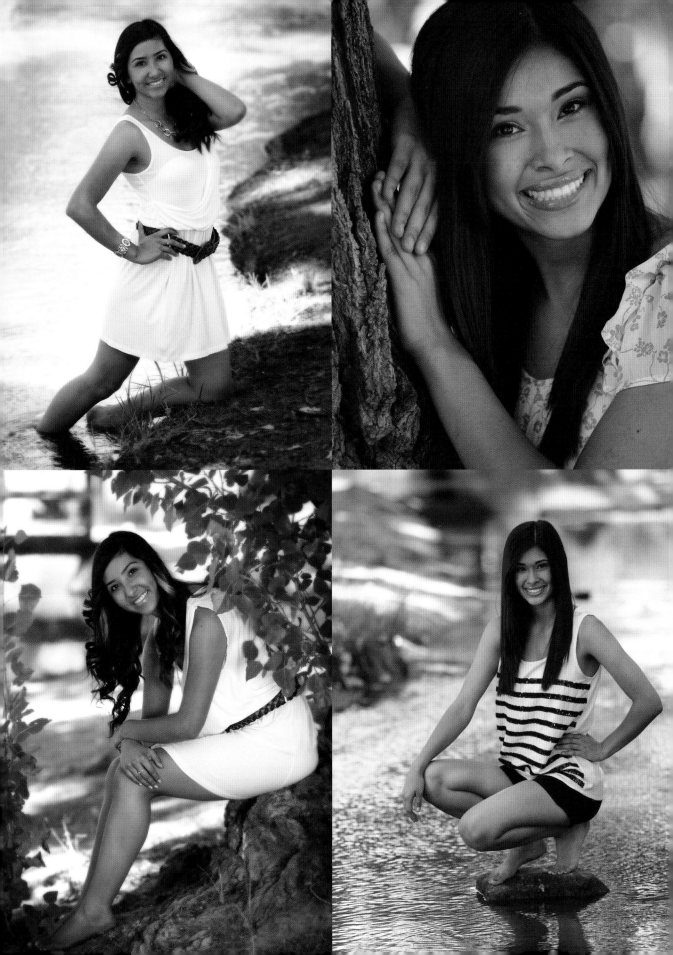

same cost as the sitting fee inside the studio. For other locations, the sitting fee is usually about four times that amount." So if I charged a $50 sitting fee to go to my park, the sitting fee I charged for going to a special location might be $200 (or more, depending on how far away the desired location was). Naturally, 95 percent of the time, the client decides that a session at the park I normally use would be just fine.

However, notice that I never tell the client no. I don't refuse to do the session, but I also don't deviate from what I need to do to create a profitable session. You have to guide clients to where they should be, and your pricing is part of this process.

Family Portraits

In my business, a portrait session at a family reunion typically includes four or five groupings. One shot will be the entire group that the person hiring me wants included (usually, that's the grandparents with all their kids, the kids' spouses, and the grandchildren). Additionally, I would photograph the grandparents alone, the grandparents with their children, and the grandpar-

▲▶ *(above and facing page)* Whatever the size of the family, your preparation for the session should include a discussion of the number of groupings and poses that will be included in your fee.

ent with their children and grandchildren (no spouses). At that point, I'm done—as the saying goes, "Elvis has left the building!"

Let's say you do a session like this and charge a $100 sitting fee for the four to five groupings. What are you going to do when an amateur photography coordinator starts suggesting other groupings that are going to make you devote more time to shooting and processing the session? Again, your sitting fee is going to have to be adapted to protect your profits.

As with requests for sessions at special locations, I don't want to just say "no way" when I get extra image requests. Instead, I find the person who hired me and remind them that, as we discussed in their consultation, they'll be charged a $25 fee for each additional family grouping. This stops everyone who isn't serious about buying photographs—and the family

tends to handle the wannabe photography coordinators on their own. I don't have to say a word.

Of course, if you are too poorly organized to put this simple clause in your agreement or too spineless to talk with your client about additional charges, you can just stay and shoot for three hours instead of one. In that case, turning a profit might mean setting your family sitting fee at something more like $300 to cover all the groupings you will be photographing.

Are you starting to see the point here? If you plan well and communicate clearly, you can actually make more money while presenting lower prices to your clients. You'll attract a lot more clients with that $100 sitting fee than the $300 one. And if those $100 bookings decide to retain you for three hours, you'll still end up collecting $300 in sitting fees to cover your

time—but the clients will be more motivated to purchase prints from all the "extra" sessions they specifically requested and paid for. If they don't, you're free to go on to another booking.

Portrait Sessions

Let's say you do a lot of portraits for professionals to use on their business cards, web sites, etc. These sessions are quick and easy—and, typically, the subject also buys some photos for their family and friends, making them quite profitable. Let's say the average session of this type lasts about twenty minutes. How much should you charge for a sitting fee?

Before I answer that, let me direct this one to you male photographers. Let's say that the next business portrait session you do is a young

real estate agent. She is 22 years old and wears everything low-cut to reveal most of her double D breasts. She also favors short skirts and high heels to show off the longest, most toned legs you have ever seen in your life. And in addition to her business attire, she also brought in some lingerie—just in case there is time for some additional photos for her boyfriend. Do you stick to the twenty-minute session or does it turn into a three-hour boudoir marathon?

With that scenario in mind, what's your session fee? Let's say you price your business portrait sessions at $40 to cover the expected twenty-minute duration. That's fine—but if you have impulse control issues and end up shooting three hours every time a pretty client walks in, you're in trouble. To stay profitable, you might need to price these sessions at $80 to $160 to cover all that overshooting (or enforce additional charges if clients want extra time, clothing changes, etc.). Again, there's no one answer. You have to know yourself and your business. If you can control yourself and reliably shoot a twenty-minute session at an attractive price (that still allows for profit), you'll draw more clients and book more of your hours for the day and week. That could mean a lot more profit, overall, than charging a high fee that scares off all but a few clients.

Weddings

"How about pricing a wedding, Jeff? What do you charge?" (I hear that a lot.) Weddings bring out all the flaws in your business system. That's because you take *so many* photos at the average wedding that all your workflow profitability issues get multiplied. If you overshoot, you have a lot to edit down, and a *lot* of time to charge

▼ Simple business portraits can be a profitable product—but only if you can create them efficiently and without overshooting.

▲ If you want to be profitable, your pricing has to be established based on a process you follow at every session.

for. If you don't fix the problems you encounter *as you take the photos* and, instead, rely on addressing them in the computer, you'd also better plan on multiplying your price by a factor of two or three if you intend to remain profitable. If you don't publish the number of hours that each package/price includes (as well as how much additional time costs, broken down into 30 minute intervals), then add $300 to $600 to the package price. There is no magic number that works when it comes to setting a price that will compensate for poor business skills.

The Final Word

You can only price your photography when you develop a standard system or process of photographing each type of client—and you stick with it. Every session of a certain type has to be *exactly the same tomorrow as it is today*, no matter how pretty, how nice, or how mean the clients are. The process of every session must be the same to set an accurate price.

Did You Factor in Your No-Show Rate?

So, let's say that you have been paying attention. You have made the changes necessary to improve any flaws in your business process and have designed a workable, profitable process for your photography business. Let's also say that you have decided to charge a $60 sitting fee for your basic one-hour session. This covers your expenses (so far so good!) and you are the master of your domain, so you have a consistent process (that is great!).

One question, though: What is your no-show rate? Most photographers make an appointment without ever charging the client, so a no-show rate of 30 to 60 percent isn't that unheard of. If you have a no-show rate of 60 percent, your $60 session just went up to $96! That is what you would have to charge to avoid losing money on the time you set aside for those sessions. (60 percent of $60 is $36, which has to be added to the base rate.) That's a much less attractive price, isn't it? What's a photographer to do?

At one point, with my two studios, we had a average cancellation rate of 34 percent, with some individual days being over 50 percent. This is *crazy*—and it resulted in a whole lot of wasted time. Then, I attended a senior-portrait program where the speaker suggested charging a each senior a non-refundable sitting fee *when the session was booked*. I immediately implemented this policy by updating all of our marketing materials and our web site. The result? Suddenly, 96 percent of my clients were showing up each day! And, knowing there was no refund, when someone had to cancel, they called in at least 48 hours in advance to reschedule. Yes, some parents did not want to prepay (our calls dropped by about 8 percent)—but those were most likely the same people who would have no-showed in the first place! I was happy to have them move on to another studio and not waste *my* time.

Basically, requiring customers to make this payment up front made it possible to for us to charge them a *lower* sitting fee, while increasing our profitability!

6. Sales Models and Pricing

Effective selling, the art of actively increasing the total purchase made by each customer, is critical for a business to be successful and especially to reach its full potential. There are many ways to sell what you create to your clients. In the current market, there are photographers successfully using them all. Which one is right for you depends on *your* business and *your* selling style.

▼ Selling prints, rather than just CDs of image files, is the best way to maximize your profits.

Print Sales

The potential to increase each sale is the reason why so many studios sell their photography *by the print*. In this model, each print the customer orders needs to be priced according to the total cost of producing it (making the print itself) *as well as* the amount needed to run your business—and enough profit to eat, drink, and be merry.

It Takes Guts

While it is the most effective way to generate sales and profits, selling photographic prints has the downside of creating a more complicated pricing system and a more complex sales system. And, let's be honest, it can also be intimidating. In fact, the reason so many photographers opt for the less-profitable "shoot and burn" approach (conducting a flat-rate session and delivering a DVD of images) is a simple lack of confidence. When you are selling prints, you have to sit down *face to face* with your clients and hear what they think of your images. But, hey—no pain, no gain! (More on selling techniques in chapter 7.)

Total Control

This face-to-face sales process allows for up-selling to achieve huge profits—but you have to be willing to learn how to sell. Selling your portraits as finished portraits is truly the most professional process. Unlike those shoot-and-burn photographers, it gives you complete control over your images, right through to the creation

◄ Selling prints requires you to sit down with clients and look at your images, helping them to decide between poses and expressions.

Learn to Love the "Business"

To be a successful professional photographer you have to like business as much as you like photography, because no one's photography will sell itself. You have to market it, book it, plan it, sell it, photograph it, edit it, package it, and deliver it. You notice that the "photograph it" entry on that list is just one of many steps that a professional must undertake in the photographic process. And don't think you can skimp on the other steps; if you put any less effort into those facets of your operation than you do on the "photograph it" step, you won't be in business long.

of the final product. You control the *exact* look of the image. If the color is slightly off, if the retouching isn't correct, or if the composition/cropping could be better, you have the ability to fix it before the client and the buying public see your work. In fact, if you look at the economic food chain of photography businesses, those businesses at the top of the chain sell their work as finished portraits.

The Image Itself, Not a Piece of Paper

When photographers first start out selling this way, they often get intimidated because they know that their clients can buy an 8x10-inch print at Costco for around a dollar. That's why it's critical to understand that you aren't selling *an 8x10 print*, you are selling *the image printed at an 8x10 size*. Clients are paying for *the image*, not the cost to print that image on paper. Until you get your mind around that fact and can confidently explain it, you will never be comfortable with selling photography.

Think about it this way: you can go to an art supply store and buy an empty canvas and a frame for the empty canvas for less than $100—but it is a blank canvas. That canvas only has value when it has something on it. Commissioning a portrait to be painted on a canvas by a true artist isn't going to cost the same as a blank canvas. Chances are, the cost would be in the thousands of dollars—because you're paying for the talent that goes into *the image on the canvas*. The same is true in photography. If someone wants your work for the price of a Costco print, hand them a blank sheet of 8x10 paper—and use the canvas and frame as an example of what they are buying. If they don't get it, they are not your customer.

You Can't Price for Your Potential Clients

This brings up an important point: to survive, you have to base your prices on your costs and your needed profit. Those amounts have nothing to do with your potential customers. I know some of you don't understand that, so let me say it again: *Your pricing has nothing to do with your potential clients.* You have to charge a price that allows you a profit to survive—period. To be successful, you must send some business away. If no one has ever com-

There are potential clients out there who will complain if you charge twice what Costco charges, basically $2.00 for an 8x10 (which is insanity for a pricing decision); conversely, there are other potential clients out there who will spend $100 for an 8x10 and not complain at all. And, honestly, for some photographers/customers, it's the quality of work that causes a problem here. If you create photographs that look like snapshots a customer can take on their own, they will not spend more than a print costs to own them. If you create images that a client can't create themselves, they will typically see the value in spending more on them—unless, again, they simply don't have the money.

Perceived Value

Once you price your work correctly and create portraits that a customer cannot shoot themselves, then you have to start dealing with perceived value. "Perceived value" is the intangible value we and/or society puts on a product or service. Why does a Mercedes cost what it does? Does it really cost that much more to produce than a Buick? In Europe, they use them for taxis! Can you imagine going to New York City, seeing an ocean of Cadillac taxi cabs—and then going home and spending $80,000 on one for yourself?

Everything from the coffee we drink, to the clothes we wear, to the car we drive, to the photography services we buy, has a perceived value. There are always lower-cost options that we could select, but we chose a more expensive brand because we perceive the value to be higher. The reason that some photographers can charge $100 for an 8x10 without clients complaining is that those photographers have

plained about how much you charge, you are way underpriced. If everyone can afford you, you are working for the wrong people.

Let's be honest, there are some people out there who want things they just can't afford. These people will make *what you charge* the reason they don't hire you—when the actual problem is that *they have no money*. No matter how little you charge, these people will complain about your pricing; everything is expensive when you have no money. You don't need to work for people like that. They need to save their money and come back when they can afford your services.

established a level of perceived value that exceeds the product's $100 price tag.

Reality Has Nothing to Do With It

Is a Starbucks latte really *so* much better than other coffee stores' offerings that we pay $7 for the sheer quality of the beverage? Is there really enough difference in the quality of the shoes that a store-brand pair of pumps costs $40 while a designer-name pair costs $1000? Reality has nothing to do with perceived value.

Is a Starbucks latte really so much better than other coffee stores' offerings that we pay $7 for the sheer quality of the beverage?

◂▸ *(facing page and right)* Everything around us has a perceived value. What are you doing to enhance the perceived value of your images and your business?

Think about the Victoria's Secret phenomenon. Before Victoria's Secret, women didn't flock to department stores to stand in line and pay high prices for underwear. The genius of the Victoria's Secret brand doesn't have as much to do with the product itself as that product's perceived value. They sell pretty much the same underwear the department store used to sell, but they display it artfully, hire glamorous models to promote it, and wrap it up in a pretty pink bag with some tissue paper. It makes ladies feel special, so they are willing to pay more for it. That's the power of perceived value!

What Creates Perceived Value

Everything you do establishes the perceived value of the work you create. A photographer who shows up in a nice suit or tux to photograph a wedding has a much higher perceived value than a photographer who thinks he is such an artist that he can show up in jeans and Birkenstocks, revealing his hammer toes to the entire wedding-day crowd.

If you work out of your home, do you have a certain small space that is your presentation area—full of beautiful images in nice frames? Or even a temporary presentation area featuring nice albums and products you intend to sell each client? Or do your clients have to sit in a messy space with last night's dinner still in the delivery box on the coffee table and children's toys all around? If I had a choice between a small commercial space to rent for a studio shooting area or a small office space to meet clients and show images, I would pick the office every time. That is where I make my money. I can create beautiful images at my home, at their home, at the park—heck, I have created huge

Your Studio's Brand Identity

In any business, you must create an image that reflects the tastes of your target market. Everything from the color scheme of your print advertising to the decor of your studio must suit your clientele. The portraits you display in your studio and the music you have playing in the background must also appeal to them. A solid, well-conceived, and consistent image lets your target market identify with every part of your business.

Potential clients should quickly be able to gauge the type of portraits you offer and roughly what they can expect to pay. Walking into your business, they should know right away whether or not it is right for them. At our studio, they see nothing but senior portraits. A bride-to-be knows right away that she's in the wrong place. Often, photographers fail to think about their studios in these terms. They pick out everything according to their personal tastes—without thinking about their clients. I have gone into studios that photograph many seniors but have only wedding and children's portraits on display. This would be like going into a Chinese restaurant and seeing sombreros and Mexican blankets all around for decoration—it wouldn't make much sense.

You should also select your decor to match your desired pricing. Many photographers want to charge more for their work, but they have an old, torn sofa in front of their studio that's been there since the 1970s. Conversely, some studios select furnishings that are too nice—and this can also be a problem. If you walked into a restaurant for a casual, low-cost lunch and saw fine art on the walls and marble floors as far as the eye could see, you might turn and leave before ever looking at the menu. As a result, you'd never find out that they had good food at reasonable prices.

orders shooting in a smelly alley! That doesn't matter. What *does* matter is what the client sees, smells, and feels when they meet with you.

The correct first meeting establishes the perceived value for your work. Get *that* right and you will be on your way to charging enough to profit and live comfortably. And, just like Victoria's Secret, you can enhance your perceived value through well-conceived advertising, displays, and even the use of nice packaging when you deliver products to clients. How we dress, how professionally we act throughout the process, how we present our products—all of these things can raise (or *lower*) the perceived value of our products when it comes down to that all-important moment: the client placing their order!

The correct first meeting establishes the perceived value for your work.

There *Are* Limits

Perceived value does have its limits. In senior photography, boutique studios used to be quite popular. Clients would literally spend thousands to enjoy a pampering, spa-like experience as the senior was photographed and the senior's mother sipped champagne with a few friends. That process started to seem a little overindulgent after the economic downturn, though. A few studios still survive using this business model—but, for the most part, the "extreme luxury" model appeals to fewer clients than it used to; its perceived value has diminished.

Different Types of Sessions Have Different Perceived Values

Even aside from the perceived value that you build into your business model and overall brand, different types of photography are generally thought to have greater or lesser perceived value—which, in turn, impacts how you can price them (again, once you get beyond the minimum point where you are covering all your expenses and making at least a little profit). For example, senior portrait photography is traditionally priced slightly less than a baby- or family-portrait session because it is offered in packages and more photographs are purchased. That is not to say that you must do this, but it is the way most studios price their work. Weddings typically have a lower cost per 8x10 than a family-portrait session—again, because of the anticipated number of photographs being ordered. The thinking is to buy in volume and save.

Senior portrait photography is traditionally priced slightly less than a baby- or family-portrait session . . .

▼ Weddings, business portraits, boudoir images—different session types have different perceived values.

Retail Markup

For the purpose of this discussion, let's say you've worked out all the numbers and know that your total cost for an 8x10-inch print is $15.50. Personally, I would never price a product at less than twice (200 percent) what it cost me, so that would be $31—for the *lowest cost* photography service. This is important because you have to build in a cushion to cover all the unexpected things that will inevitably come up as you run and grow a business. For example, let's say you want to increase the number of photographs you sell each month; that will require an investment in marketing and advertising to make it happen.

The normal markup for selling retail items is 4 to 7 times (400 to 700 percent markup), but there has to be some flexibility. Some photographers used to recommend calculating the total print and retouching charges and then multiplying that by 6 or 7 or 8. Unfortunately, this gives you a number that may be too low for your situation or too high for the area you work in. For instance, a wedding album is usually a high-ticket item (it costs the photographer a lot to produce and have manufactured), so adding a 400 to 700 percent markup might price you right out of the market. You still have to add a markup and make a profit, but something more like a 200 percent markup might be more appropriate—it's a place to start. Pricing requires finding a balance between charging what you have to in order to live, while not increasing your prices so much it paralyzes you when it comes to sales. Even when creating packages (albums, frames, folios, photo mounts), you have to profit from every item you sell.

While there are many ways to price your photography, they all have to start by clearly defining what you have to charge *in your situation*. Any other way of pricing your work is just a guessing game.

Don't Be the Cheapest

The way you sell any product gives a potential client a preview of the quality of product they are purchasing. You don't expect the jewelry you get from a street vendor to be of the same quality as a piece you purchased at Tiffany, right? You don't expect the same quality food from a restaurant with a drive-through as from one that is elegantly decorated with a full wait staff, correct? If you are buying art pieces for your elegant home, you don't go to Walmart do you?

In every market, there are businesses that find their niche—whether it is buying and selling the finest products or the cheapest ones. Potential clients then select the business that fills the

▲ A photography session is a big deal to most people – so they aren't generally shopping for the cheapest option. They want quality.

niche they are looking for. Many photographers think *every* client is looking for the cheapest price. I don't have a daughter, but even if I weren't a photographer, I would know not to go to the cheapest photographer in town for her wedding photos. A once-in-a-lifetime event and I am going to shop at the equivalent of Walmart or Big Lots? No way! I would go to a photographer I knew would produce beautiful images of my little girl's most important day—and I'd pay accordingly. People *do not always want the cheapest option*; if they did, luxury automobile companies, designer clothing brands, gourmet grocery stores, and fine-dining establishments would not exist.

Without understanding this, many young photographers get trapped in a vicious circle. They start out too cheap (because they feel like everyone in their market is competing to be "the cheapest") and then they can't increase their prices because everything

> Businesses that find their niche – whether it is buying and selling the finest products or the cheapest ones.

▶ If people only shopped on the basis of price, luxury brands would simply not exist.

about their business says they are cheap, like selling a CD with the images on it. Potential clients expect to pay a certain amount of money for a CD of images—just like they expect to pay $.99 for a drive-through hamburger. Those "cheap clients" have already called every photographer in town to see who is the cheapest, and that's all they're going to pay. Clients who will spend *more* don't want to go to the photographic equivalent of a drive-through restaurant. They want professional portraits that are presented in frames so they can go home and enjoy the beautiful images they just purchased. Just like fine restaurants don't have a drive-through, better photographers don't sell CDs (or at least not primarily CDs; read the next section for more on this). You may argue, but this is the view the buying public has—and it's one of the main factors that determine the perceived value of the work you create.

Selling Digital Files

After reading that last section, I know that some of you are already thinking, "That's old-school thinking!" But I'm not saying that releasing your digital files is always a bad idea—only that you probably won't make as much money as you could if that's the primary (or only) product you provide. I think it's a mistake to get into that "old vs. new" mode of thinking, anyway. Photography will always be traveling in new directions, and the people who are going to profit are those who keep their minds open and balance fresh ideas with tried-and-true ones to maximize their business.

◄► *(facing page and right)* Selling digital files isn't a bad idea – but you won't make as much money as you could if that is *all* you sell.

The people who are going to profit are those who keep their minds open and balance fresh ideas with tried-and-true ones.

When It Works

Since some of you were in grammar school, I have been offering my seniors the digital files for the images *they ordered from*—because that's a great way to increase the size of the order and maximize my profits. Likewise, if you consistently charge $1000 to $2000 for images on a DVD/CD, you are obviously doing something right and have managed to break through the stereotype that the buying public has—but if you do that, you are definitely not the average photographer selling digital files only.

Why, More Often, It Doesn't

There are three primary reasons that selling only digital files is problematic. Here they are:

Problem One: Low Perceived Value. So, your client spends a thousand dollars and you hand them . . . a CD or DVD? Really? Typically, people who have money to spend on a nice portrait session don't want to waste time having to print and frame everything themselves. We are in a service business, and handing

▼ People like having framed prints for their homes – but most won't quickly get around to printing and framing images they receive only as digital files.

someone a DVD isn't providing them a service. It reminds me of a commercial for the investment firm Edward Jones. In it, a patient sits at a kitchen table and holds a scalpel poised over his body. On the phone, his surgeon begins explaining how to make the first incision for the operation. Incredulous, the patient asks, "Shouldn't *you* be doing this?"

If your sales process ends with you handing the client a DVD, who will help them determine the correct size for their wall

portrait? Who will explain the compositional changes that occur when ordering prints that have different aspect ratios? Who will explain *anything*? As professionals, shouldn't we see our clients through the entire process instead of just throwing them a DVD after the shoot? As professionals, isn't that our *job*?

Problem Two: Low Quality. The second problem with selling only digital files is one of quality. Who is going to print your images for each client? Just the other day, I needed some 5×7s of a new dessert for my restaurant. I was already on my way to Costco, so I had my son upload the images and place the order on-line. This was, of course, a fast solution—but when I picked up the images, they all had a slight purple cast and were very dark. They looked great when the order was placed, so I knew it wasn't a problem with the file. It was a problem with the way the machines were calibrated or operated at the Costco.

> As professionals, shouldn't we see our clients through the entire process instead of just throwing them a DVD after the shoot?

◀▶ *(facing page and right)* Selling prints is the best way to maintain control over how your images are displayed – including the quality and color balance of the prints.

Now, imagine this happening to your client. What would they do with those dark, purple portraits from, say, their newborn's session? And how would they feel about you as a professional photographer? Do you think they'll come back for another session? Or recommend you to all the friends in their birthing class who are also about to become new parents? You just lost a lot of business.

Problem Three: Your Sale Is Limited. The final problem with selling *only* digital files is probably the worst from a business standpoint: you have capped the size of each sale. The client has all the images, so what else are you going to sell them? Wall portraits, frames, portfolios, additional gift portraits, and wallet-size prints are the things that help pay the bills on the slow months. When someone loves their images and has the money, those are the sessions that will drive the profits of your studio. Those big sales—the ones that are often four or five times larger than your average client's purchase—are what will allow you and your family to have the nice things in life . . . like food and shoes for your children. Passive systems do not allow for those big sales.

Pricing for Digital File Sales

If you still decide to deliver your work only on CD/DVD, the pricing process should be the

same as we've already covered for pricing prints. Break down the average number of images you give to the client on the disc. Then, total up the amount of time you spend creating and editing each image. Dividing the total expenses by the total number of images you sell each month tells you how much you need to charge, per image, just to break even. The cost will probably amaze you. In most cases, this is because you're shooting and editing a lot of images compared to the number you are actually selling.

The only workable solution for this type of sales/delivery process is to have a set price—let's say $300—for a session that includes a DVD of their favorite four images, fully edited, and unedited copies of the rest of the images that were taken. While this would limit your profit and income potential, it would at least ensure you make a profit, if only a small one!

Billing by the Hour

The last pricing system is one that has been used by commercial photographers for years: billing by the hour, plus expenses.

For Weddings

This system has been modified for use with weddings, where the bride and groom purchase your time at a discounted rate

because they are basically buying in volume. Most wedding photographers charge a fixed rate for each hour of their time, then discount the price of each portrait or product (because they have already been partially compensated for their time).

When I did a lot of weddings, I had my "get out of bed on a Saturday" charge. I saw my wife and children enjoying their weekends, and all

the other dads out playing with their kids, so I had a minimum hourly rate I built into the packages. This helped compensate for having to get out of a nice warm bed and work all day while the rest of the world was having fun. In most of my wedding plans, I added a charge of $150 per hour for my time. So, if the wedding plan included five hours of photography coverage, $750 of the total purchase price was just to cover *me*. This was *above* the minimum dollar value needed to cover all of my costs and ensure a profit, as we've already required is the bare minimum for sustainable pricing.

For Portraits

When you present a client with a DVD that contains four edited portraits as well as a copy of all the unedited images for a certain dollar amount, as I proposed in the previous section, you are really using this model; you are charging the client for your time plus your expenses.

While using this delivery/sales process for portraiture is easy to understand and lets you turn a basic profit, it limits your sales potential and profit. It's okay to start with, provided that you account for everything and charge a realistic fee for a professional service.

While I used $300 in my earlier example of this pricing model, that was an arbitrary number. In most photographers' situations, that won't be a high enough price to sustain a profitable business. Again, though, there are no magic numbers that you can use to determine your pricing. Although . . . I guess you could charge $500 for every 8x10 and sell at least two hundred of those a month. If you can do that (*hint:* virtually no one can do that), then I suppose you don't have to put any more thought into your pricing!

In most photographers' situations, that won't be a high enough price to sustain a profitable business.

7. Selling Your Photography

Effectively selling your photography is really only possible if you sell prints; with any other sales model, you're leaving money on the table. Billing a client for your time plus expenses, or for images on a DVD, are both passive delivery systems—which is why so many younger photographers use them. "Passive" means you don't have to present images to the client and take their order. You simply get the money, hand them a DVD, and say "Everything is on there—now let me get out of

▼ Active selling helps you earn more and deliver products that are better tailored to your clients' needs.

here before you see the images and start yelling!" The problem with passive delivery systems is you will never sell more than the basic DVD. I hate to be negative, but rarely will an order come in once the client has paid for a DVD or your time and is in possession of the image files. (That's not to say that delivering image files is always wrong; we've already looked at how it can work.)

Selling Larger Portraits

Selling means finding out what people want and helping them to get it. Unfortunately, people don't want what they tell you they want. Does anyone really *love* a portrait and want an 8x10 to put on a bookshelf? Yes, they *say* they want an 8x10 of that beautiful portrait you created of their precious daughter—but, really, they would like it the size of their garage door so they can see that sweet little face from anywhere in the house!

Profit and Marketing Benefits

The best way to increase your profit is to sell *larger* portraits, not additional smaller portraits. Wall-size portraits are more profitable portraits than 8x10s—and it takes just as long to record an order for a 20x24 as it does an 8x10 or two 5x7s! Additionally, once a big, beautiful portrait goes up on the wall of a client's home, it is like a billboard for your business. Make sure you have a readable logo or watermark on the image so everyone knows who created the portrait. In the early days of my career, this marketing technique helped me pay the bills. At weddings, I would watch the social order of each family, then invite an attractive family that was high in the social order to do a family portrait. I would

do whatever it took to get a family portrait up on the walls of their home. Yes—a few times I gave away a 20x24-inch print with a frame, but it was the best money I have ever spent on advertising.

The Right Decision for Their Home and Budget

Selling photography is simply a matter of finding out what each customer really wants and then helping them to get it. When it comes to wall portraits, that means determining what is appropriate for their home and their budget.

The Proper Size. The "proper" size for an image depends on the size of the face (or faces) within the frame and the room in which it will be viewed. Obviously, the smaller the facial size, the larger the entire portrait must be to be able to see the faces and enjoy the faces from anywhere within the room where it is hanging. Price should have no place in this part of the determination; the proper size doesn't change just because you are working with a poor family or a rich one.

I once photographed a family in a house so small I could barely fit the entire group into the frame—even with a wide-angle lens. This family purchased a 30x40-inch print and later had

The "proper" size for an image depends on the size of the face (or faces) within the frame and the room in which it will be viewed.

Selling Is Serious Business

Take selling seriously. Either learn to sell professionally or hire a good salesperson to sell your images for you. If you decide to hire someone, make sure their sales experience is with a *professional* product (not cars, vacuum cleaners, or other "high-pressure" items). If you decide to do the sales presentation yourself, spend some time studying the psychology and language of professional selling—again, not high-pressure selling.

When I first attempted face-to-face selling, I was scared to death. My first sales appointment was a little rough. I stuttered and I said the wrong things at the wrong times—but I still sold a 20x24- and two 16x20-inch prints to the parents of two smaller children. Up to that point I had never sold anything larger than a 16x20, and I had never sold multiple wall portraits from the same session. Despite the bumps in the road, this made me an instant believer in actively selling my product rather than hoping for an order.

the old house torn down to built a new house around my portrait. (Okay—I'm exaggerating! It turned out they were planning to build a new house but wanted a portrait taken in the old house, where all the children grew up.) There were thirteen people in that photo and, for the room where it was hanging, it was the perfect size. At the time of the session, though, I was surprised that the family who lived in such a modest little home had the money for the portrait—but the father paid cash. You never know, so you have to present every portrait session as though you know they can afford whatever print is the right size for the room where they plan to display the image.

Can the print be too big? Sure. I have guided almost as many clients to a smaller print with a very large facial size as to a larger size print for an image with a very small facial size. In senior portrait photography, we do a lot of close-ups and fashion-style head shots. Many of the moms initially want a 20x24-inch print of that style of portrait, but that would make the facial size larger than life. You want to see the eyes of the subject(s) from anywhere in the room—but you don't want the face size to be so large that it dominates your attention when you walk into the room. If they want to display a print of this size, an image with a smaller facial size would be a better choice and provide greater enjoyment for the viewer.

There are books available on the proper sizing and placement of art. If you feel like you could use some advice on making these design recommendations to your clients, buy one and study it.

The Client's Budget. In most cases, the client's finances will keep them from buying too

large a portrait for their home. However, even the most frugal person in the world has soft-spots—purchases that will make them open their wallet and let large amounts of money come pouring out! For some people, it might be a new car or truck (my father-in-law, for example, starts using words like "only" when he is talking about a $150,000 RV!). Many people break out of their frugality when it comes to things that involve their children. Typically, however, there is still one person (Mom or Dad) who is more ready to move forward than the other, so you'll have to get that parent excited enough to overcome the other's resistance.

I realize that some photographers feel uncomfortable when it comes to encouraging a larger investment than the client initially seems eager to make. Think about it this way: if you don't help a client get what they *really want*, who is the real loser? The client is. You can make more money at the next session; you can create meaningful portraits for the next client you work with. If the client doesn't get to fully enjoy a portrait of someone they love, you have let them down!

To Sell Large, Show Large

If I had you take a photo of my two sons and myself, I would want a wall portrait—something I could see and enjoy. Most *photographers* would make the same decision. If, however, I was not a photographer and saw only paper proofs and a price list, I wouldn't know what size I wanted. I would probably pick an 8x10 because it is a size

◄► *(facing page and right)* If you don't help the client get what they really want, who is the real loser?

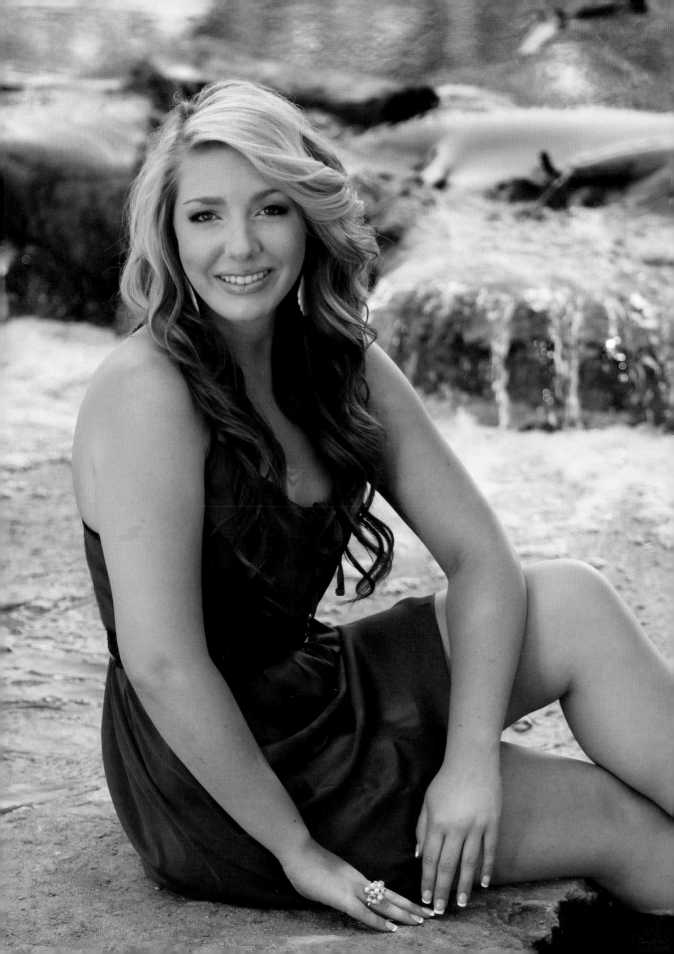

I am familiar with. However, if you took the time to *show* me all the different sizes available (especially if you could do it on the wall where I would be hanging it!), I would gladly spend some serious money to have a portrait of my boys and myself. Don't believe it? Well, I have a 40x60-inch print in my home of just such an image! The photographer who shot it realized that, no matter who it is, you never know what people are going to buy until you show them—and he enjoyed the difference in profit between a 40x60 and an 8x10!

Set the Stage for Success. To *sell* wall portraits, you must *display* wall portraits. Whether clients meet you in your home or at a commercial space, they should see it decorated with the kind

> Whether clients meet you in your home or at a commercial space, they should see it decorated with the kind of large portraits you hope to sell them.

◄► *(facing page and right)* Showing the client all the different sizes available – and how they look with different face sizes in the images – will help steer them in the right direction when purchasing prints.

of large portraits you hope to sell them. Frankly, if you don't have wall portraits in your home, you are in the wrong business. If you don't feel that what you create is important enough to be displayed in your home, you will never be able to sell it. I have wall portraits all over my home of my boys and family at different times in our lives together. There isn't a day that goes by I don't find myself looking at those photos, remembering the times and places they were created—remembering that stage of my life and my sons' lives. We create a product that is important to the people we create it for. If you can show your clients, right from the start, how important you know photography is in our lives, you will be more effective in selling it.

Make a Huge First Impression. At the sales session, the first thing a client sees is what will stick in their minds—it's what they will want to buy. So if you want to sell large portraits, that should be the first thing your client sees. (For this presentation, show images—don't make a slide show. You are there to sell a *wall portrait*, not spend all night having them ask you if they can buy the slide show or get it thrown in for free!)

I find that the best way to show images is using a projector with a zoom lens. In the client's home, I hang a nice dark-wood frame on the client's wall where the portrait will most likely hang. This frame is filled with a white piece of foam-core board, so I can project the image right onto it. With the zoom lens on the projector, I can show them approximately the image size we're discussing—right on the wall in their room, so they don't have to imagine how it will look. If you're on a limited budget, make arrangements to use the largest television in the home. Hook up your laptop to the television and start showing and selling!

Get the most important element of a successful sale working for you: excitement.

Guide the Discussion. As you show the images, refer to each size by price. "This size is $3250. How do you think that would look hanging right there?" If they complain, gasp, or yell, "That's crazy!" then calmly say, "Is it the size or the price that bothers you?" If, as is virtually always the case, the client says it's the price, then reply, "Well, this is the price on canvas, which is the finest finish we offer. If we put it on our standard finish, it would only be $2800. How do you feel about that?" You continue until you reach a point where they don't want the print to be smaller or you've reached a price they feel comfortable paying.

Shoot to Show

As I've noted in previous chapters, showing the client their images right after the session gets the most important element of a successful sale working for you: excitement. Excitement sells—ask any salesperson. When you are in the moment and most excited about the product, that's when you are most likely to overcome your fear of making a poor money decision and actually *buy*.

Therefore, I shoot to show—meaning I know before the session if the wall space allows for a vertical or horizontal image. Whatever the spacing allows is the way I do any and all images that might go there. If you have a vertical space but decide to do one of the groupings horizontal—just for something different—that's typically the one they will like the best. Then, you can only sell a 16x20-inch print, because you only have 20 inches of width. They lose and you lose! If I am showing portraits to a family who had several groupings done, I talk with my client beforehand and know which portrait grouping is the most likely to be selected as a wall portrait.

Shooting to show also requires that I make the image look 95 percent as good as the final image will be. The lighting, posing, and scene must be perfect as it is captured. You can't have hotspots on the subjects and trash in the background of the photos. I show five to eight images of each idea, with a variety of expressions. Depending on the family, I will explain the differences in the poses, as far as good and bad expressions or subtle differences in poses and the way they affect the overall look. Some families do very well on their own.

◀▶ *(left and facing page)* Once the wall portrait is selected, continue to go through the other images and products. Don't limit your sale to that one purchase!

Sell Additional Products and Groupings

Once the wall portrait is selected, I continue showing and selling the rest of the groupings. Don't forget that you can sell more than one wall portrait. Try saying something like, "Well, you have the wall portrait of the entire group for your home—but wouldn't this one of just your family be perfect for your office?" Always go through every grouping and every image. Also, go through every product you sell and show examples. If you do groupings, collages, or folios, bring them and show them. The client doesn't have to buy, but often they will. Don't ever cut a sales session short because *you* think they have bought enough. Let them say, "I think that is it!"

Develop a Sales System

I could write a book on the sales process of photography—but the best advice I can give you is to develop a consistent sales process that works and never deviate from it. You can never tell which customers will be the ones to place large orders, so you have to go through *all* the steps of the sales/viewing process every time—no matter what kind of car the customer arrived in and no matter where they live. If you do, you will often be surprised.

Let's be honest, the reason many photographers select a passive sales approach is that they fear the comments clients will make about their photography. But fear, like most things, can be used for good or bad. Fear cripples most people; they live a life of

> The best advice I can give you is to develop a consistent sales process that works and never deviate from it.

meager means because of all they fear. As Mark Twain wrote, "I've had a lot of worries in my life, most of which never happened." Fear, or thoughts of problems, keeps many of us from achieving our goals—even though the things we fear rarely happen. So, turn that fear on its head and let it motivate you to become better.

When I decided to run a business that sold professional photography (instead of a photography studio that took pretty pictures), I decided that the only way to live the way I expected to live was to *sell my work*. I also realized that the only studios that consistently produced large orders were those that didn't let their photography leave their studio. Whether it was a viewing after the session was over, like we easily do now with digital, or a scheduled appointment after the transparency proofs were printed from the negatives, the customer could only see and have the opportunity to order *in the studio*.

Let's face it. When customers see their portraits and have copies (even small ones) at home, procrastination takes over. In the early days of my studio, I waited up to three months for customers to return their originals (a nice word for "proofs"), so I finally implemented a policy that clients would pay a deposit to take proofs out of the studio. The client was billed for the full value of the proofs after four weeks if there was not a return date scheduled. If the customer kept the proofs and *didn't* pay for them, the matter went to collections, because they signed an agreement acknowledging this charge would be made. While this system did increase cash flow and get more clients to order, it also put me at odds with many clients—or people who would have been clients if I had just handled the process more delicately.

Today, our clients are all informed that the ordering session will be right after the shoot is over. What is the one thing that a client might say after you tell them this? "What if I don't have the money to order after the session?" When we hear that, we ask that they simply wait to book the session until they have money to order. People don't go to the grocery store to *look* at the food on the shelf, right?

To run a photography business, you must develop a business plan that focuses on selling the photography you create.

We also don't offer portrait visitation, which is what a lot of our past clients who couldn't really afford the session to begin with seemed to want. "I can't afford to buy," they'd say, "but I really want to see the photos." And when you call back in two weeks, they say, "Well, I'm still not ready to order—but I would like to come in and show my mom the photographs!" This is portrait visitation. Don't do it.

In all your information, given in writing and verbally to the customer to prepare them for their session, explain your viewing and order policies, then stick to those rules. You will see your profits increase and your business grow. This is what takes you from having a hobby to running *a business*. It is fun to take pretty pictures—but if that is all you want to do, get a job and be a hobbyist. To run a photography business, you must develop a business plan that focuses on selling the photography you create.

8. Are Your Prices Working?

So, how do you figure out if your pricing is working? Or if you need to be booking more sessions per day? You have to sit down and evaluate your sales. A hard, objective look at the right numbers will help you figure out if your pricing or volume needs to be adjusted so you'll be making more than a bread-and-water living. If you discover a problem, don't act like a photographer and think, "Maybe I don't need health insurance for my family." Instead, think like a businessperson and say, "All I have to do is increase my average order by X (one print, a set of wallets, a parent album, etc.) and I will get my sales level where I need it to be."

▼ The final step in pricing is critically evaluating whether it is working. How much money are you actually making? Is it enough?

Sales-Per-Client Averages Don't Tell the Whole Story

Every year, I go to conferences and hear at least one of the featured speakers talk about his or her impressive sales averages. Unfortunately, averages calculated on a per-client basis are a vague measurement of a fairly straightforward accounting process. This means that when you talk about averages you can double-talk your way around profitability. Using averages gives you too much flexibility in the numbers you present.

For example, as a business person, I would figure my sales average by taking the total number of people I photographed and dividing that by my total sales—that gives me a true average of the amount of money I brought in per client. If I wanted to sound more impressive, though, I could factor in only the sales

Looking at the average sale per client can be a breeding ground for unprofitable workflow practices and bad habits.

◄► *(left and facing page)* Your average sale per client isn't a good indicator of your profitability. What counts is how many hours it took you to bring in that money.

figures of those clients who *ordered* and divide that by number—omitting the losses from no shows, people who decided not to order, and everyone who got laid off between booking the session and ordering and couldn't afford to buy any products. Another way photographers mess up this calculation is by applying the sales figures from their *best* month to the entire year.

Looking at the average sale per client can be a breeding ground for unprofitable workflow practices and bad habits. In this profession, we have many photographers who appear to be at the top of our profession, yet they are still editing their own images. Do you see doctors running their own lab tests or lawyers doing their own case filings? Of course not—because these professionals realize they have only a certain number of billable hours in any given year, and there is always a cap on the maximum amount that a professional can realistically charge per hour. You worth per hour isn't based on what you think; it is it based on what your clients will pay.

Calculate Your Sales Per Hour

When you are in business, you're far better off considering your sales per hour—the amount of money you're bringing in for the total number of hours you spend working. This includes the hours you spend on work you take home with you, too! You only have so many billable hours; if you aren't generating $300, $400, $800, or $1000 in sales per hour, *for every hour you work*, you aren't running a business. You, my friend, have an expensive hobby.

This is, or could be, the downfall of many of the "boutique"-type studios that we always hear about. Try wrapping your mind around

this example. There are two photographers. One is an average photographer, while the other is an accomplished boutique studio owner. The average photographer sees one client per hour for an eight hours day. Since he is just "average" in his abilities, he generates about $300 in sales per hour. You then have the boutique photographer; he's an excellent photographer and has an $1,800 average order from each client. This sounds much better, doesn't it?

However, to justify the prices that he charges, the boutique photographer devotes a lot of time to his clients, giving them that level of personal attention we associate with the

"boutique" feeling. He starts meeting with the clients in a consultation, he takes three hours to photograph them, he makes a custom slide-show presentation, personally edits the images and projects them for each client. When all is said and done, the boutique photographer has spent seven hours of his time getting that $1,800 order. That amounts to $257.15 in *sales per hour*. Are you still impressed?

If you are going to trade away your time at home, the love and respect of your spouse and children, and even your health (from too many sleepless nights), it should be for a hell of a lot more than $257.17 in sales per hour. Because, remember, that number is *sales* not *profit*. Out of that $257.17 per hour, you still have to cover all of your business expenses—employees, rent, utilities, insurance, taxes, lab bills, equipment costs, bookkeeping, travel, web site hosting, marketing, etc.

Less Is Actually More

Most studios will make more profit on a simple session with a talented photographer than a super-sized session that takes three hours. If you personally shoot three-hour sessions, I have to ask—what in the world do you *do* for three hours? Do you break out a board game or a deck of cards? In a one-hour session with a senior or family, I can take more photographs than my clients can actually view. Taking any more would put me into the downward "overshoot and edit down" spiral that so many unprofitable studios subscribe to today.

This is not something I'm basing on anecdotal evidence, either. We keep very accurate records and have found that as the size (duration, number of images) of the sessions increase, the size of the order *doesn't increase proportionally*. Sure, a three-hour session—going outdoors, to an urban location, and then finishing in the studio—sounds like fun to a photogra-

pher . . . but unless this session can generate three times the sales of a session done in just the studio, you are shooting yourself in the foot. The same things happens with wedding photographers and the time they spend shooting at weddings. Not too many weddings can be done with two hours of photography time, but if you do sell a package that has only two hours of coverage, a larger package that has six hours of time had better generate at least three times as much in sales.

Our average studio session is one hour. While some seniors opt to book multiple sessions (studio, outdoor, urban), the sales from these almost never make up for all the additional time—even when we add in a higher sitting fee. To deal with this problem, we have developed special products for the larger sessions that help bring up the sales per hour. Adding a minimum print order for these "super sessions" is another way of handling this problem, ensuring the total sale will be commensurate with the time invested. However, we also present those standard one-hour sessions (our most profitable!) to clients as "what everyone does." When you tell a client that a *less* expensive product is "what everyone does," they tend to believe you and follow your advice!

Adding a minimum print order for these "super sessions" is another way of handling this problem . . .

My Top Two Rules

The largest problem that most photographers have when dealing with these issues is getting over the "I'm an artist" mentality and beginning to think like a businessperson. So here are my top two rules:

1. As a professional who wants to live well, you have to control your billable hours and always evaluate your success based on your sales per hour—nothing else.

2. Delegate every task other than photography to someone else. I don't meet with my clients. I don't get them ready for their session. I don't set up the backgrounds, download the images, present the photos, edit the selected images, print the portraits, or deliver them. I photograph—because I am a photographer, and I generate the most money with a camera in my hands.

Conclusion

Go Back to the Basics

You can make a good living as a professional photographer. You can successfully turn a hobby you love into career that supports you and your family—or revitalize a business that isn't fulfilling its earning potential. If you're willing to buckle down, do some math, and correct your income-devouring bad habits, you can do it!

The first step forward is actually taking a step back: you must go back to the basics. Start off by looking at the smallest package or session on your list. Figure out your sales per hour at that level. Are you making a livable wage? If not, think about how you could change your pricing, efficiency, or sales model to get you where you need to be. Then, start looking at the larger sessions and packages—the ones that involve even more of your time. Make sure that your average sales per hour goes up proportionately (and definitely not down).

That's it! If you can take control of these few variables and manage them consistently, you can run a profitable photography business and do what you love to do—*professionally!*

> The first step forward is actually taking a step back: you must go back to the basics.

Index

Dream Weddings

Celebrated wedding photographer Neal Urban shows you how to capture more powerful and dramatic images at every phase of the wedding photography process. *$27.95 list, 7.5x10, 128p, 190 color images, order no. 1996.*

How to Photograph Weddings

Twenty-five industry leaders take you behind the scenes to learn the lighting, posing, design, and business techniques that have made them so successful. *$27.95 list, 7.5x10, 128p, 240 color images, order no. 2035.*

Photographing Newborns

Mimika Cooney teaches you how to establish a boutique newborn photography studio, reach clients, and deliver top-notch service that keeps clients coming back. *$27.95 list, 7.5x10, 128p, 180 color images, order no. 2030.*

Photograph Couples

Study images from 60 beautiful wedding and engagement sessions. Tiffany Wayne shows what it takes to create emotionally charged images couples love. *$27.95 list, 7.5x10, 128p, 180 color images, order no. 2031.*

ABCs of Beautiful Light

A Complete Course for Photographers

Rosanne Olson provides a comprehensive, self-guided course for studio and location lighting of any subject. *$27.95 list, 7.5x10, 128p, 220 color images, order no. 2026.*

Step-by-Step Wedding Photography, *2nd ed.*

Damon Tucci offers succinct lessons on great lighting and posing and presents strategies for more efficient and artful shoots. *$27.95 list, 7.5x10, 128p, 225 color images, order no. 2027.*

Classic Family Portraits

Ed Pedi walks you through the process of designing images that will stand the test of time. With these classic approaches, photos become instant heirlooms. *$27.95 list, 7.5x10, 128p, 180 color images, order no. 2010.*

Shaping Light

Glenn Rand and Tim Meyer explore the critical role of light modifiers in producing professional images of any subject, ensuring smart decisions at every turn. *$27.95 list, 7.5x10, 128p, 200 color images, order no. 2012.*

Shoot to Thrill

Acclaimed photographer Michael Mowbray shows how speedlights can rise to any photographic challenge—in the studio or on location. *$27.95 list, 7.5x10, 128p, 220 color images, order no. 2011.*

One Wedding

Brett Florens takes you, hour by hour, through the photography process for one entire wedding—from the engagement portraits, to the reception, and beyond! *$27.95 list, 7.5x10, 128p, 375 color images, order no. 2015.*